POSTCARD HISTORY SERIES

St. Mary's County

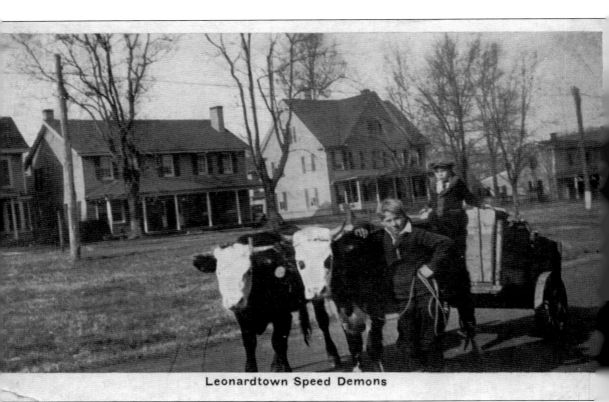

Leonardtown Speed Demons

BYGONE DAYS IN OLD ST. MARY'S. In an image from the 1920s, two young men visit the heart of Leonardtown in an oxcart. Nearly a century later, asphalt paving has replaced dirt streets, and stores sit where homes once fronted the town square. (Courtesy of the Jack and Karen Grubber postcard collection.)

ON THE COVER: HOTEL ST. MARY'S. The Hotel St. Mary's was located on the square in Leonardtown from 1907 to 1956. (Courtesy of the Jack and Karen Grubber postcard collection.)

POSTCARD HISTORY SERIES

St. Mary's County

Karen L. Grubber

ARCADIA
PUBLISHING

Published by Arcadia Publishing
Charleston, South Carolina

Printed in the United States of America

Library of Congress Control Number: 2014953655

For all general information contact Arcadia Publishing at:
Telephone 843-853-2070
Fax 843-853-0044
E-mail sales@arcadiapublishing.com
For customer service and orders:
Toll-Free 1-888-313-2665

Visit us on the Internet at www.arcadiapublishing.com

This book is dedicated in honor of my parents, Ann Hewitt Grubber and Jack Grubber, and in memory of the first Hewitt family historians— Alphonso Hewitt, Joan Hewitt Burroughs, and F. Frederick Hewitt.

CONTENTS

ACKNOWLEDGMENTS

I am grateful for the kind assistance provided by Ann Hewitt Grubber, Jack A. Grubber, Mary Lillian Hewitt, George A. Kirby III, Carol Moody, Ronald Pegg, Kent Randell, Pearl Hewitt Roundtree, J. Daniel Simpson, Frank Tippett, George Tsirigotis, William B. Wagoner Jr., Susan Wolfe, the National Trust Library Historic Postcards Collection, the St. Mary's College of Maryland Archives, the St. Mary's County Historical Society, and the University Archives at the University of Maryland. This book could not have been published without your help—many thanks. Unless otherwise noted, all images appear courtesy of the Jack and Karen Grubber postcard collection. The author's proceeds from this publication will benefit the St. Mary's County Historical Society.

INTRODUCTION

St. Mary's County is a living dichotomy, mixing modern ways with centuries-old traditions. Amish farmers cross paths with electrical engineers. The commanding officer of a cutting-edge military organization lives on the site of the 17th-century home of one of Maryland's first governors. Dinner guests might be served sushi or crab cakes cooked according to an old family recipe.

While times may change, one thing is constant: The people of St. Mary's County always welcome visitors with warmth and hospitality, proud to share their land of pleasant living. As one writer described nearly 150 years ago, "The [people of St. Mary's] are just the same as of yore—staid, refined and aristocratic. The same warm hearts, the chivalrous bearing, the gallantry of old, are here to welcome the stranger and make that seeker after comfort and pleasure feel that his or her lines have been well cast."

Bounded by the Potomac and Patuxent Rivers on the north and south and the Chesapeake Bay on the east, St. Mary's County enjoys over 500 miles of pristine shoreline. The county is also a fertile agricultural area. For centuries, farmers grew highly profitable tobacco, replaced in the 21st century by corn, soybeans, and wine grapes.

As the "Mother County" of Maryland, St. Mary's has a rich written history that begins in 1634, when George and Leonard Calvert established a colony founded on the principle of religious tolerance. Soon after, Margaret Brent, one of the most prominent women in Colonial America, became the nation's first suffragette, demanding a vote and "voyce" in Maryland's general assembly.

During the War of 1812, county farmers endured frequent raids by British troops, who plundered supplies, destroyed tobacco crops, and harassed the citizenry while trying to convince Washington to abandon the war. Meanwhile, many enslaved servants found freedom by escaping to British ships.

In the Civil War, the county's sympathies were divided. Some favored the North and served in the Union army, while others slipped across the Potomac River and enlisted in the army of the Confederacy. One of the nation's most notorious prison camps was located at Point Lookout, but local citizens were more likely to help prisoners escape to Virginia than return them to the camp.

At the beginning of the 20th century, St. Mary's County produced some of the finest bootleg whiskey served in the nation's capital. People from Washington and Baltimore flocked to the county's summer resorts, which offered relaxation, outdoor recreation, and spectacular food. City children attended popular waterfront summer camps, learning to fish and crab and making lifelong friendships.

When World War II began, the US Navy established the Patuxent River Naval Air Station and built Lexington Park to house the influx of workers. The base later was expanded to include the Naval Air Test Center, the Navy's premier flight-testing center, and the US Navy Test Pilot School, which trained many of the first astronauts.

Today, St. Mary's County has a population of over 105,000, many of whom moved to St. Mary's to work for the Navy or one of its defense contractors. Leonardtown, the county seat, has grown from a dirt crossroads into a prosperous economic center undergoing several revitalization projects. Despite these changes, millions of Americans trace their roots to Southern Maryland and are welcomed home as "Sons and Daughters of Old St. Mary's."

One

LAND OF HISTORY

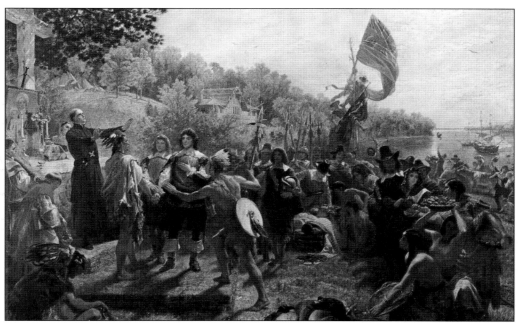

THE FOUNDING OF MARYLAND. St. Mary's County is the birthplace of Maryland and religious tolerance. In November 1633, seventeen gentlemen adventurers, three Jesuit priests, and 140 others boarded the ships *Ark* and *Dove* bound for the New World. The settlers were searching for a better life and a home where all religions could be practiced freely. On March 25, 1634, the ships landed at St. Clement's Island, located on the eastern shore of the Potomac River. (Oil on canvas by Emanuel Gottlieb Leutze [1816–1868], original on display at the Maryland Historical Society, Baltimore, Maryland.)

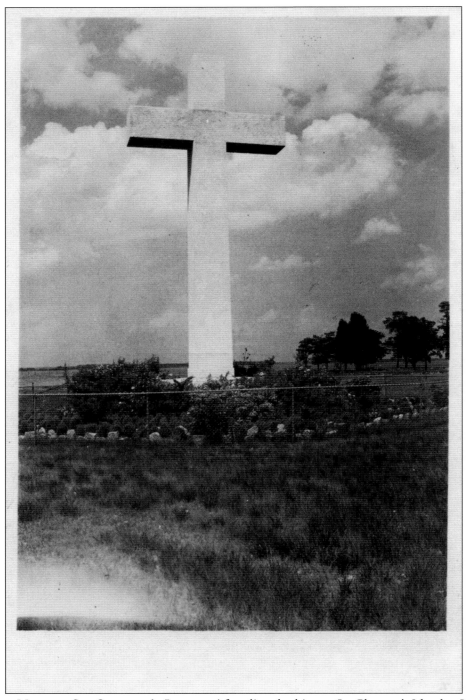

FIRST MASS AT ST. CLEMENT'S ISLAND. After disembarking at St. Clement's Island, a Jesuit priest, Fr. Andrew White, celebrated mass in thanksgiving for the settlers' safe arrival. In 1934, the tercentennial of Maryland's founding, a 40-foot cross was erected on the south side of the island to commemorate the settlers' bravery and honor the idea of religious tolerance.

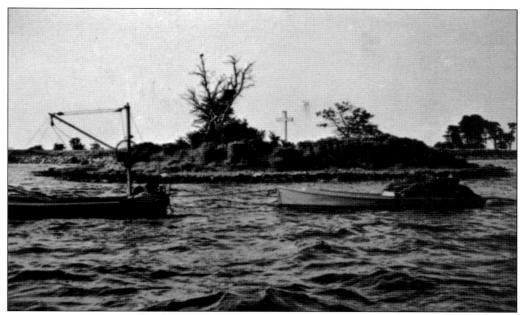

BLESSING OF THE FLEET. Each year, before the start of the oyster harvesting season (October 1), the Optimist Club of the Seventh District sponsors a two-day festival on St. Clement's Island dedicated to local seafood and honoring Maryland's first settlers. The festival is capped by a Catholic mass and blessing of scores of boats moored around the island.

6573 VIEW of ST. MARY'S RIVER from ST. MARY'S CITY, MD. PUBL. BY ST. MARY'S PARISH

A NEW HOME ON THE ST. MARY'S RIVER. Soon after landing at St. Clement's Island, Maryland's first settlers began exploring the Potomac River's tributaries in search of a location for a permanent settlement. They purchased an existing Yaocomaco Indian village located on the banks of the St. Mary's River and named it St. Mary's City. In this postcard from the 1920s, the river looks much like it would have appeared in colonial days.

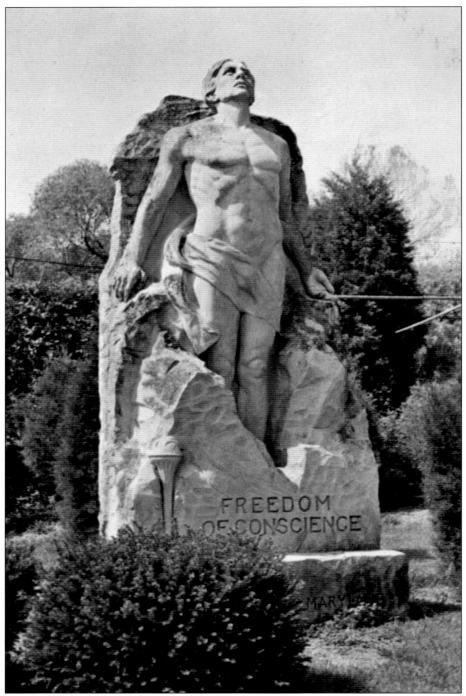

FREEDOM OF CONSCIENCE. Erected in 1935 at the entrance to St. Mary's City, the *Freedom of Conscience* statue was a gift to the state from its 23 counties in commemoration of Maryland's tercentennial. The statue was sculpted by Hans Schuler Sr. (1874–1951) and honors religious and civil freedom in Maryland. (Courtesy of George A. Kirby III.)

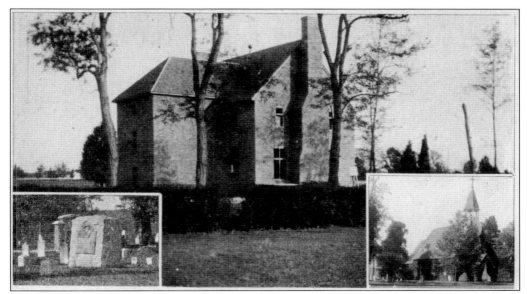

THE STATEHOUSE. In 1676, an elaborate brick statehouse was constructed in St. Mary's City. Six years later, the building was "so leaky and decayed as will hardly secure the records of the province." After the capital was moved to Providence (now Annapolis) in 1694, the statehouse was converted to a chapel for the Church of England and later the Protestant Episcopal church. In 1829, the building was dismantled, and the bricks were used to construct Trinity Church. This image shows the reconstructed statehouse in the 1930s. (Courtesy of St. Mary's College of Maryland Archives.)

RECONSTRUCTED STATEHOUSE. In conjunction with Maryland's tercentennial, the statehouse was reconstructed about 300 yards southeast from its original location. The design was based on a detailed 17th-century description and includes an assembly room, governor's council chamber, and arsenal. Bricks for the walls surrounding the statehouse were taken from the ruins of Carthagena, an early 18th-century plantation owned by William Hebb and later Benjamin Hewett.

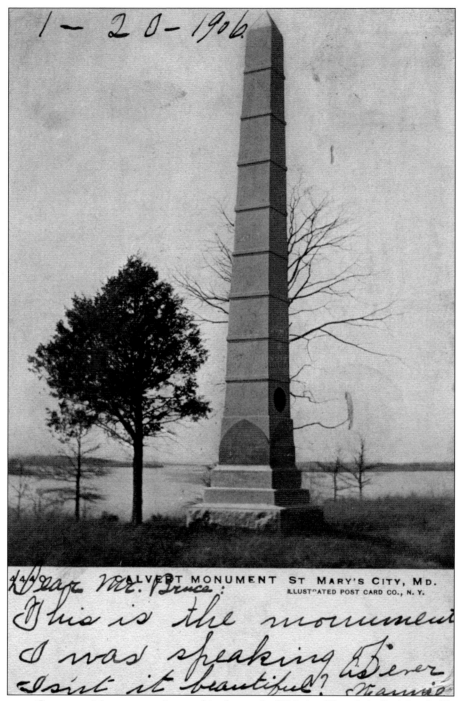

LEONARD CALVERT MEMORIAL. Located in the yard of Trinity Church in St. Mary's City, this granite obelisk was erected by the State of Maryland in 1890 in memory of Leonard Calvert, the leader of the first expedition to Maryland and its first proprietary governor. It is the oldest existing commemoration of an early Marylander.

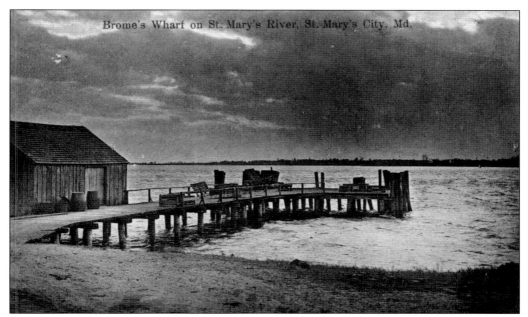

Brome's Wharf on St. Mary's River, St. Mary's City, Md.

Brome's Wharf. After Maryland's capital was moved to Annapolis in 1694, the population of St. Mary's City dwindled, and the town slowly reverted to farmland. Around 1840, Dr. John Mackall Brome constructed a house on the banks of the St. Mary's River directly over the ruins of the 17th-century home of Leonard Calvert. The road to Brome's Wharf, which is believed to have been constructed in the 1630s, is still in use today.

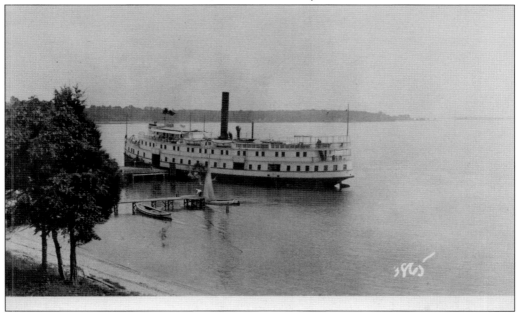

Steamship at Brome's Wharf. Dr. John Mackall Brome became a prosperous tobacco farmer and entrepreneur. In the latter half of the 1800s, he constructed a steamship wharf to ship tobacco to market in Baltimore. The wharf served St. Mary's City and the St. Mary's Female Seminary until August 1933, when it was damaged in a hurricane.

15

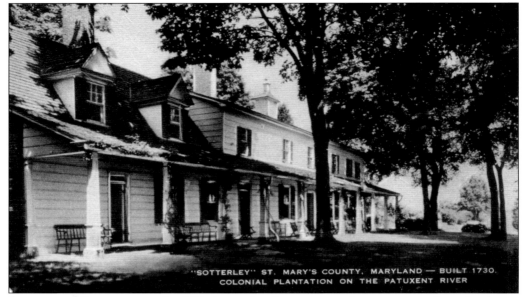

"SOTTERLEY" ST. MARY'S COUNTY, MARYLAND — BUILT 1730.
COLONIAL PLANTATION ON THE PATUXENT RIVER

SOTTERLEY PLANTATION. In 1703, James Bowles constructed a two-room plantation house on the banks of the Patuxent River. Over the next two centuries, the house was enlarged by successive owners, including four generations of the Plater family, eventually becoming one of the most impressive tobacco plantations in the tidewater region. Today, the plantation retains the name of the Plater family's ancestral seat in England, Sotterley Hall.

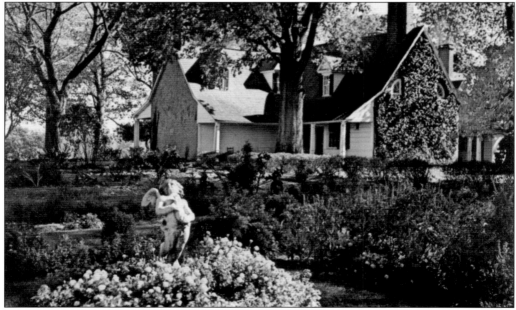

GARDENS AT SOTTERLEY. After purchasing Sotterley in 1910, Herbert L. Satterlee and his wife, Louisa, daughter of J.P. Morgan, planted an extensive Colonial Revival garden, including a cutting garden, vegetable plot, herb garden, and perennial beds. Plantings included boxwood, rambling roses, a large peony hedge, and numerous flowers. Now tended by the Sotterley Garden Guild, the beautiful gardens continue to delight both casual visitors and horticulturalists.

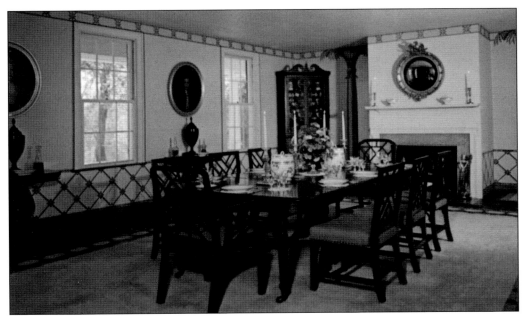

DINING ROOM AT SOTTERLEY. By 1780, George Plater III, the sixth governor of Maryland, had transformed Sotterley from a modest house into an elegant mansion, adding a dining room, drawing room, formal entryway, and second floor. The dining room's palm tree–motif wallpaper was a 20th-century addition by Sotterley's last private owner, Mabel Satterlee Ingalls.

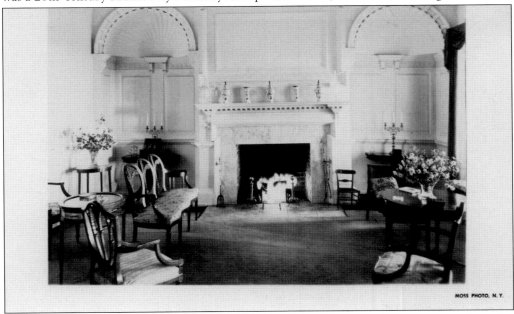

MOSS PHOTO, N.Y.

DRAWING ROOM. With the exception of the plaster ceiling, the entire drawing room at Sotterley is carved from pine and poplar wood, including shell alcoves and an ornate mantel. One of the room's window panes is etched with the name Key. According to one popular legend, this is where Governor Plater's daughter tested the authenticity of her diamond engagement ring from Philip Key, the uncle of Francis Scott Key.

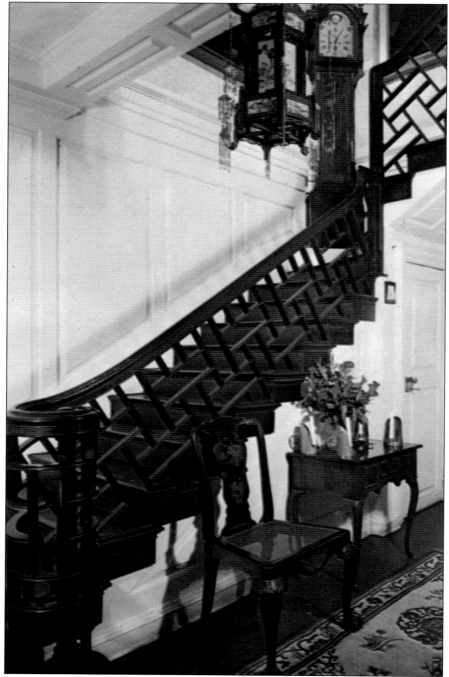

CHINESE CHIPPENDALE STAIRCASE. Sotterley's central staircase is one the plantation's most renowned features. It was built by Richard Boulton, an expert joiner and carpenter. George Washington subsequently hired Boulton to finish a room at Mount Vernon, but Boulton never traveled to Virginia to perform the work.

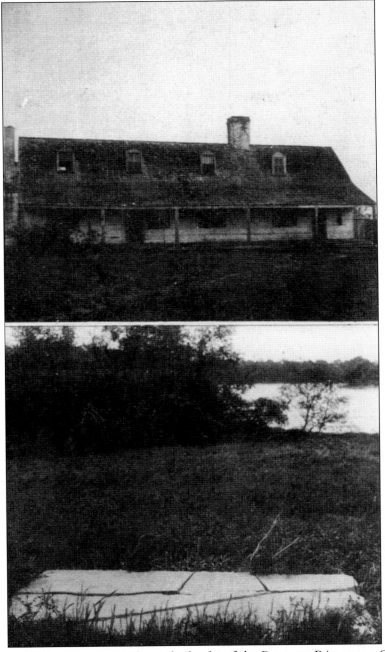

SUSQUEHANNA PLANTATION. Built on the banks of the Patuxent River near Cedar Point, Susquehanna Plantation was believed for many years to be the 17th-century home of tax collector Christopher Rousby, whose weathered tombstone is pictured here. Subsequent studies determined the house was built by Henry and Elizabeth Carroll in the 1830s. The Carrolls were one of the wealthiest families in Maryland, owning 700 acres of land and 75 enslaved Africans. Susquehanna was purchased by Henry Ford and moved in 1942 to the his Greenfield Village in Dearborn, Michigan. (Courtesy of St. Mary's College of Maryland Archives.)

MATTAPANY-SEWELL MANOR. Originally a Jesuit mission, Mattapany was patented in 1663 by Henry Sewell, the secretary of Maryland. After building a small house, Sewell died; his widow married Charles Calvert, proprietary governor and later the third Lord Baltimore. The couple occupied Sewell Manor from 1666 to 1684. The plantation served as a seat of government and arsenal and was the scene of the Protestant Revolution of 1689, which overthrew Maryland's proprietary government. The original manor house was replaced in the mid-18th century. After undergoing extensive additions and renovations in the 19th and 20th centuries, Mattapany now sits within the grounds of Naval Air Station Patuxent River and serves as the home for the commanding officer of the Naval Air Systems Command. (Courtesy of St. Mary's College of Maryland Archives.)

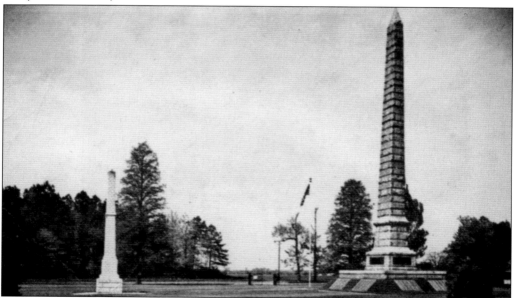

POINT LOOKOUT CONFEDERATE CEMETERY. During the Civil War, the Point Lookout peninsula became the largest prison in the North for captured Confederate soldiers. Conditions were horrific, and approximately 4,000 of the 50,000 prisoners died while imprisoned. Located just outside of Point Lookout State Park, a mass grave for more than 3,000 soldiers is marked by two obelisks: a 25-foot white marble monument erected by the State of Maryland in 1876 and an 80-foot granite monument raised by the federal government in 1911.

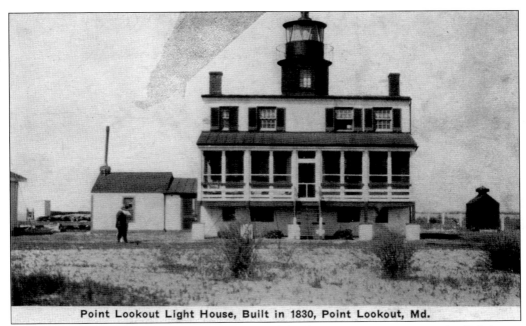

Point Lookout Light House, Built in 1830, Point Lookout, Md.

POINT LOOKOUT LIGHTHOUSE. In 1830, the federal government constructed a lighthouse at the confluence of the Potomac River and the Chesapeake Bay. After a century of civilian operation, the lighthouse was transferred to the US Coast Guard in 1939. In 1966, the lighthouse was deactivated, and the associated structures were turned over to the US Navy. (Courtesy of St. Mary's County Historical Society.)

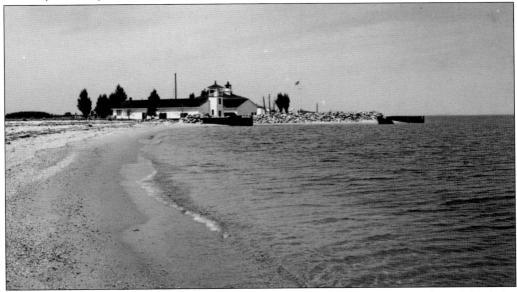

POINT LOOKOUT LIGHTHOUSE, 1970s. After the US Navy assumed ownership of the Point Lookout lighthouse, it installed electronics equipment related to testing operations at the nearby Naval Air Systems Command at Patuxent River. This image shows the lighthouse's buoy and coal sheds soon after the Navy occupied the property. (Courtesy of St. Mary's County Historical Society.)

THE LAST THREE NOTCH TREE. Before European settlers arrived, a Native American trail known as the Patuxent Path ran nearly the length of St. Mary's County, separating the watersheds of the Potomac and Patuxent Rivers. In 1704, state law directed that roads leading to a church or courthouse should be marked with trees cut with two notches, and roads leading to a ferry should be marked with three notches. Patuxent Path soon became known as Three Notch Road, reportedly because it led to the ferry at Benedict-Leonardtown (now Benedict, Charles County). The last three–notch tree, pictured here in 1934, was located two miles north of Hollywood on State Route 235. (Courtesy of St. Mary's College of Maryland Archives.)

Two

CHURCHES

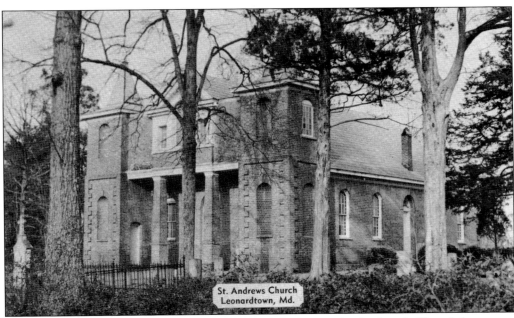

ST. ANDREW'S EPISCOPAL CHURCH. Built around 1766, St. Andrew's Church houses an Episcopal parish established by the Maryland Provincial Assembly in 1744. Richard Boulton, the church's architect, is credited with creating the structure's magnificent woodwork, including its ornate altarpiece.

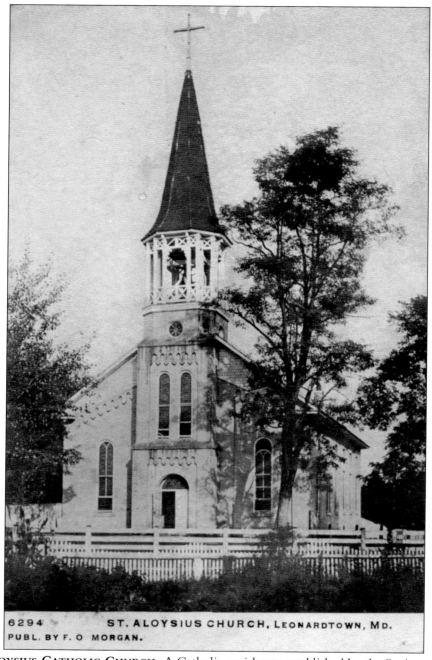

6294 ST. ALOYSIUS CHURCH, LEONARDTOWN, MD.
PUBL. BY F. O MORGAN.

ST. ALOYSIUS CATHOLIC CHURCH. A Catholic parish was established by the Society of Jesus in Leonardtown (then known as Seymour Town) in the early 1700s. Masses were initially held in parishioners' homes. Around 1766, a wooden church was built about a mile north of the current church. The second St. Aloysius Church, pictured here, was built in 1846 on land donated by James and Ann Blackistone. By 1959, the church was suffering from signs of age and was condemned. Masses were held in the adjacent Fr. Andrew White School until a new church opened on March 18, 1962.

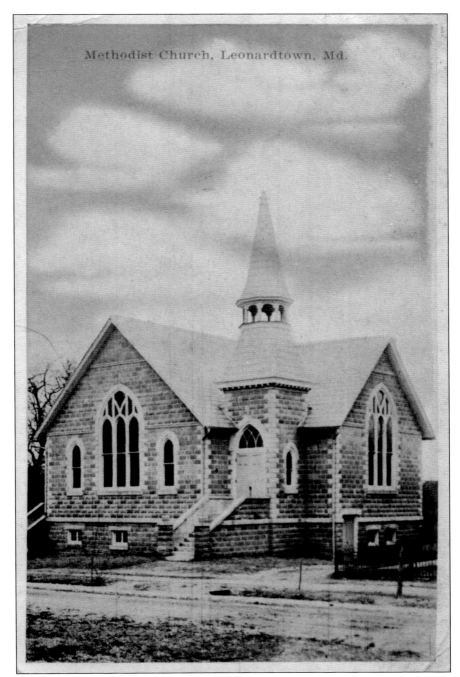

Methodist Church, Leonardtown, Md.

ST. PAUL'S UNITED METHODIST CHURCH. Located in the heart of Leonardtown, St. Paul's Church was constructed in 1914–1915 on land the Leonardtown Circuit of the Methodist Episcopal Church purchased from Harry M. Jones for $1,750. The Gothic Revival building was constructed using stone and six types of ornamental concrete blocks molded on-site by builder Lafe Graves. The church was sold to St. Paul's Methodist Church, Inc. in 1963 and Leonardtown Nazarene Church Foundation in 1991.

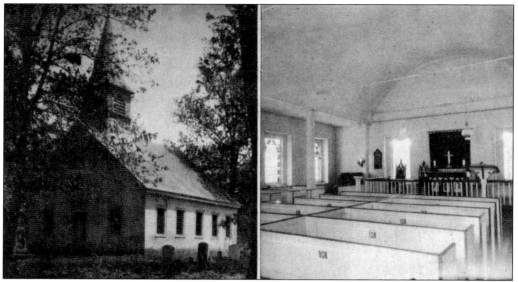

ST. GEORGE'S PROTESTANT EPISCOPAL CHURCH. An Episcopal parish was established in Valley Lee around 1638, less than four years after settlers landed on Maryland's shores. Dubbed William and Mary Parish by the Maryland Provincial Assembly in 1692, St. George's is known colloquially as Poplar Hill Church. The parish has been served by four church buildings. The existing church, pictured here in the late 1920s, was built in 1799. (Courtesy of St. Mary's County Historical Society.)

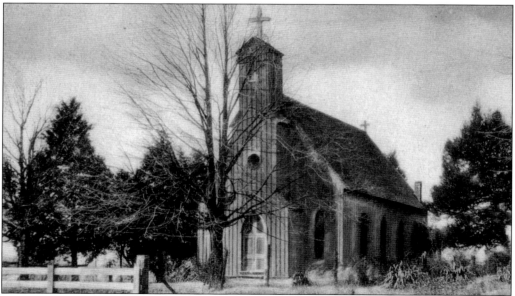

ST. PETER'S EPISCOPAL CHURCH. St. Peter's, a frame Gothic chapel located in Leonardtown, was constructed in 1871 as a chapel of ease for parishioners of St. Andrew's Parish. At that time, St. Andrew's Church was in poor repair and used only during temperate weather or for special occasions. St. Peter's was the parish's primary worship center until deemed structurally unsound in 1985. Philip H. Dorsey III subsequently purchased the building and converted it into office space in 1987. (Courtesy of St. Mary's County Historical Society.)

OUR LADY'S CHURCH AT MEDLEY'S NECK. Colonial records suggest a Catholic chapel was located at Medley's Neck as early as 1648. In 1765, Rev. Fr. George Hunter, a Jesuit superior, purchased two acres of land on the south side of Breton Bay on which a church had been prebuilt by James Gough. At that time, Catholic priests were permitted to buy land but prohibited from building churches. The original structure was closed in 1816 due to safety concerns; it was replaced by a brick church in 1817. The current structure, pictured here in the early 1920s, was built in 1910 and dedicated in May 1911. (Courtesy of St. Mary's County Historical Society.)

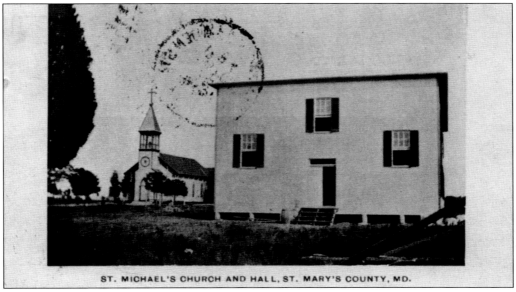

ST. MICHAEL'S CHURCH AND HALL, ST. MARY'S COUNTY, MD.

ST. MICHAEL'S CATHOLIC CHURCH. St. Michael's began as a mission of St. Ignatius Parish. In 1823, land was purchased in Scotland for the construction of a church. The first substantial church building was constructed in 1881 but was abandoned only seven years later because the land was low and poorly drained. In 1888, a new church, pictured here, was built two miles north in Tall Pine (later renamed Ridge). A two-story social hall was constructed in 1912, and St. Michael's School opened in that building in 1918. In 1922, after 16 religious orders declined to staff the school, the Sisters of St. Joseph of Hartford, Connecticut, began a 77-year tenure teaching there. In 1950, a new school building was erected; it was expanded in 1960 and again in 1999.

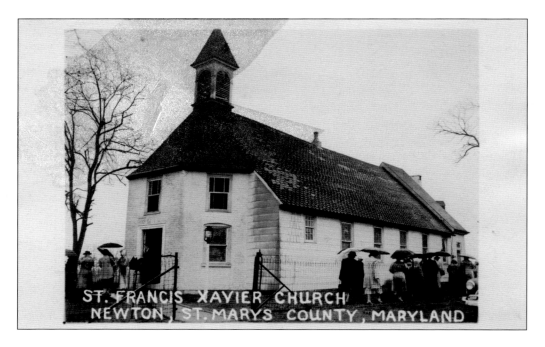

ST. FRANCIS XAVIER CATHOLIC CHURCH. In 1640, William Bretton invited Jesuit priests to create a mission on 750 acres located on Newtowne Neck. A wood-frame church was constructed around 1662. The current church, which dates to 1731, was carefully constructed to avoid appearing Catholic because the open practice of Catholicism was prohibited in those days. In 1767, a two-story, brick, semi-hexagonal addition was constructed, creating a choir loft and front vestibule. A matching brick addition was built onto the back of the church in 1816.

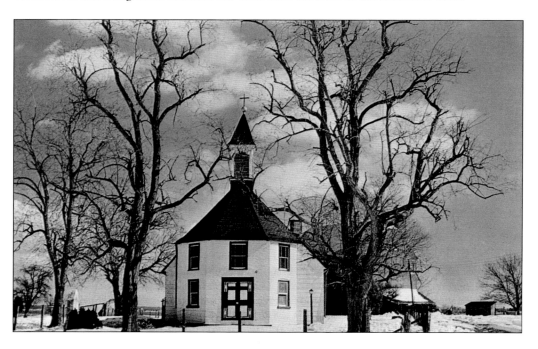

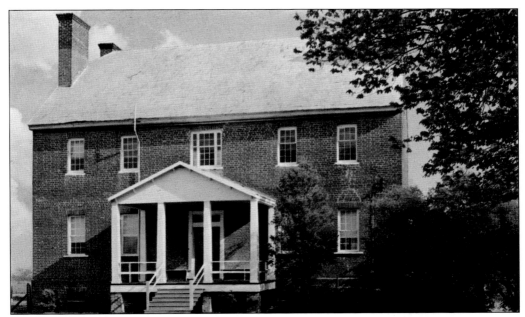

NEWTOWN MANOR HOUSE. Jesuit priests established a mission at Newtowne Neck within a few years after the founding of Maryland. The Jesuits quickly constructed a manor house that also served as an early school. The current structure, believed to be the third manor house constructed on the property, was built in 1789. In 1967, the Society of Jesus deeded the property to the Archdiocese of Washington, ending over 300 years of Jesuit residence at Newtowne Neck.

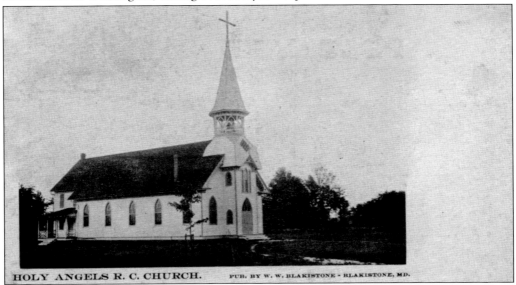

HOLY ANGELS R. C. CHURCH. PUB. BY W. W. BLAKISTONE - BLAKISTONE, MD.

HOLY ANGELS CATHOLIC CHURCH. Until the early 1900s, Avenue was a mission area of Sacred Heart Parish in Bushwood. Mass was celebrated at mass stations at the homes of local Catholics, including Haverman Mattingley, Mary Jane Berk, Whittie Burch, and Louis Mattingley. Holy Angels Chapel was constructed in 1904. Two years later, on the Feast of the Guardian Angels (October 2, 1906), Holy Angels was recognized as an independent parish. A new church was dedicated on September 9, 1962, and the original chapel, pictured here, was torn down.

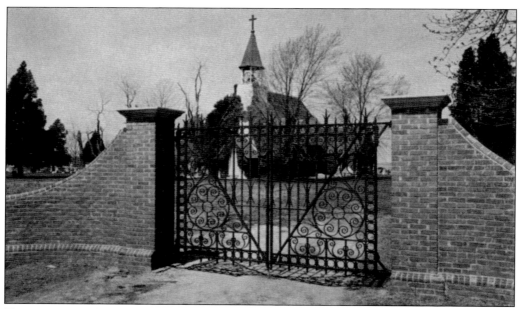

TRINITY CHURCH GATE. The entry to Trinity Episcopal Church in St. Mary's City features an elaborately worked, wrought-iron gate installed in the 1930s. The gate was forged by the same blacksmith who created the ironwork for the Washington National Cathedral. (Courtesy of St. Mary's College of Maryland Archives.)

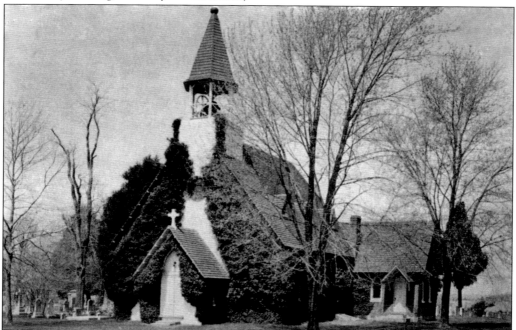

TRINITY EPISCOPAL CHURCH. The first Trinity Church was built near Ridge around 1638. In 1642, a wooden church was constructed in St. Mary's City. From 1695 until the early 1800s, services were held in the old statehouse. In 1829, the current church was built using bricks from the deteriorating statehouse.

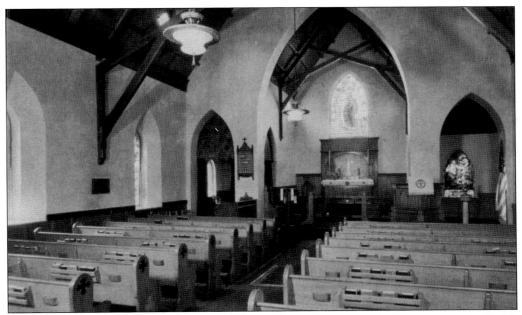

INTERIOR OF TRINITY CHURCH. Trinity Church's interior was originally constructed of brick and wood. In 1937–1938, the falling floor was replaced with flagstone, and new lighting fixtures and an electric organ were installed. A limestone altar was also added in the 1930s. (Courtesy of St. Mary's College of Maryland Archives.)

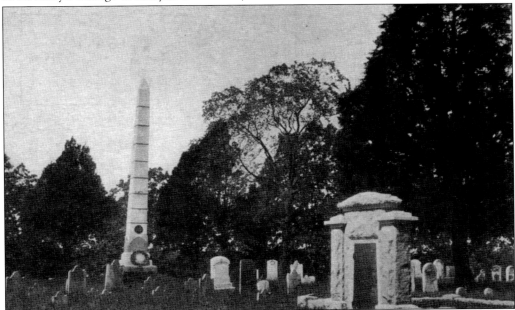

TRINITY CHURCH GRAVEYARD. The prominent obelisk pictured here is the Leonard Calvert Memorial. The arched doorway on the right is the Copley Memorial, the resting place for Lionel Copley, the first royal governor of Maryland appointed after the Protestant revolution overthrew Lord Baltimore in 1689. Copley and his wife, Lady Anne Boteler Copley, are entombed beneath the memorial in lead coffins protected by a subterranean brick vault.

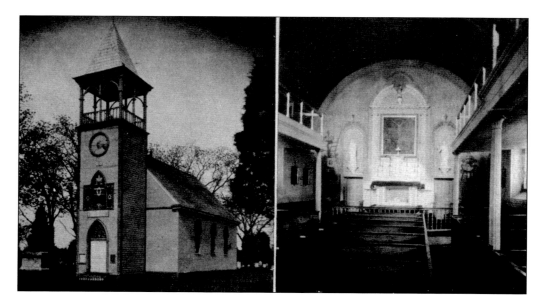

ST. IGNATIUS CATHOLIC CHURCH. The first St. Ignatius Church was a brick chapel built in 1641 in St. Mary's City. In 1704, all Catholic churches were closed by order of the royal governor. St. Ignatius was dismantled and the bricks taken four miles downriver to St. Inigoes, where a large Jesuit manor house was built. The current church was built between 1785 and 1788 within sight of the St. Inigoes manor house. A sacristy was added in 1817 and an extensive renovation performed in 1933. Regular services were held in the church until 1930; today, the church is used for special occasions and an annual Maryland Day mass. (Above, courtesy of St. Mary's College of Maryland Archives; below, courtesy of the Jack and Karen Grubber postcard collection.)

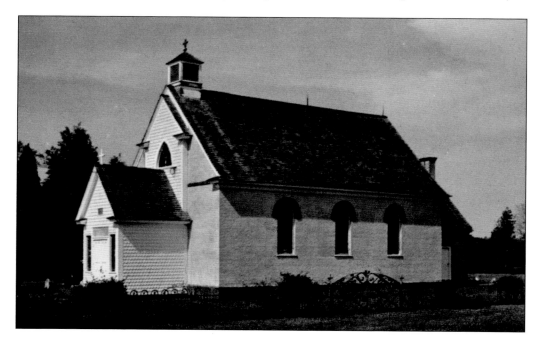

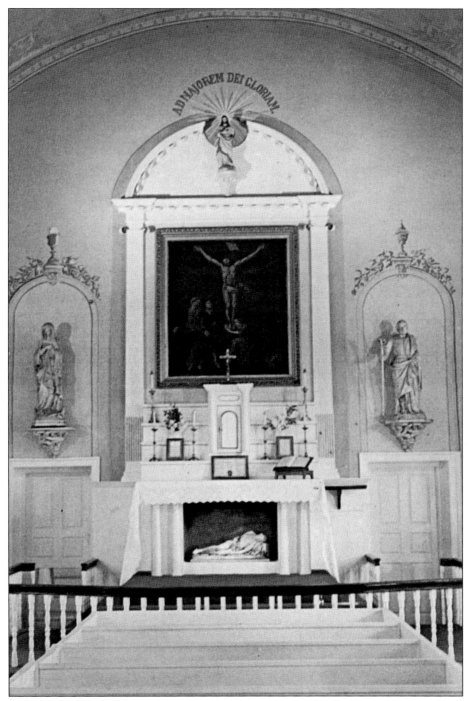

ST. IGNATIUS INTERIOR. The interior of St. Ignatius Church features three rows of boxed pews divided by two aisles and a U-shaped gallery supported by columns. The altar, surrounded by a communion rail, is supported by tapered columns. A painting of the crucified Christ hangs behind the altar. Elaborate frescoes once covered the interior walls and vaulted ceiling.

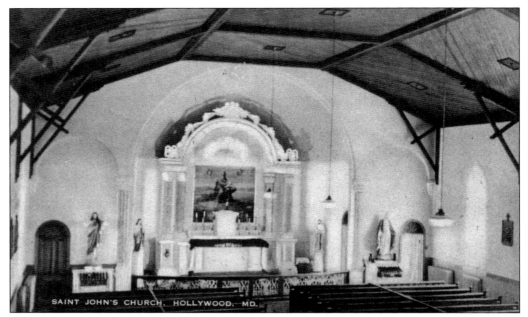

St. John Francis Regis Catholic Church. The first Catholic church located in Hollywood was built around 1690 and situated by an artesian spring approximately 180 yards northeast of the present church. A second church was built around 1780, and the third and current church was erected in 1898.

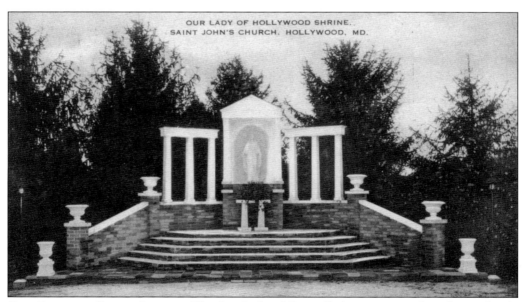

Our Lady of Grace Shrine. The Our Lady of Grace Shrine was erected on the south side of St. John's Church in the Marian year of 1954 to honor Mary, the Blessed Mother. The shrine was damaged by a falling tree during a severe storm in 1997; restoration work was completed in 1998.

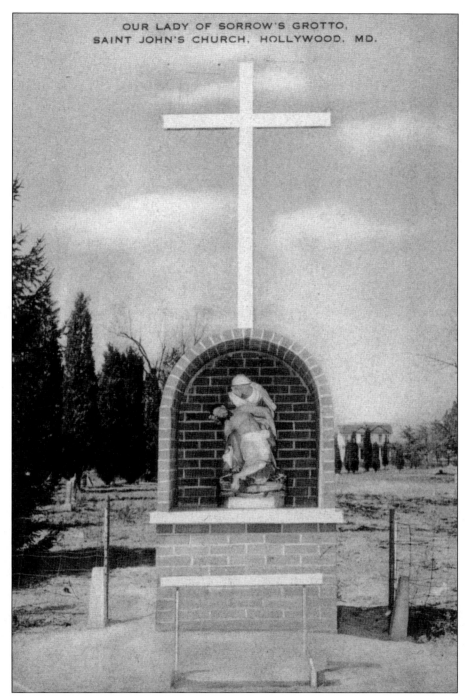

OUR LADY OF SORROW'S GROTTO,
SAINT JOHN'S CHURCH, HOLLYWOOD, MD.

OUR LADY OF SORROWS GROTTO. In 1955, the parishioners of St. John's Church erected the Our Lady of Sorrows Grotto on the north side of the church. The grotto contains a statue of the crucified Christ with the Blessed Mother, a gift from St. Peter's Catholic Church in Jersey City, New Jersey.

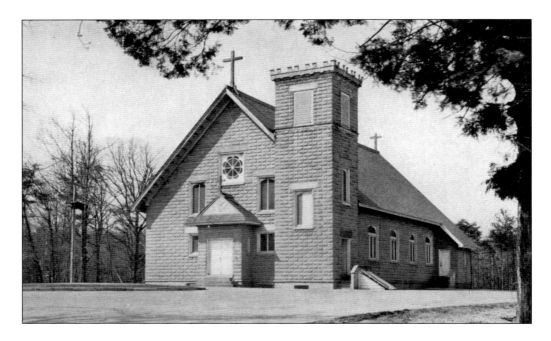

ST. NICHOLAS CHURCH. A Catholic church was built near Mattapany (the current site of Naval Air Station Patuxent River) in the late 17th century and replaced around 1795. In 1916, a molded concrete-block structure was built to replace the 1795 frame structure. When the Navy base was established in 1943, the church was converted to a multidenominational base chapel. At that time, tombstones in the church's graveyard dating back to the 18th century were buried or destroyed; beginning in 2003, Scott Lawrence, an amateur historian, and James Gibbs, an archeologist, recovered and restored nearly 300 of the tombstones. The church remains in use today.

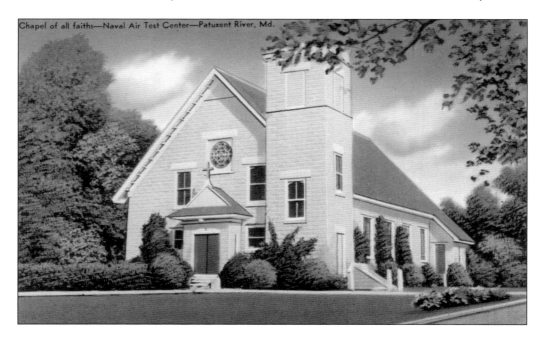

Chapel of all faiths—Naval Air Test Center—Patuxent River, Md.

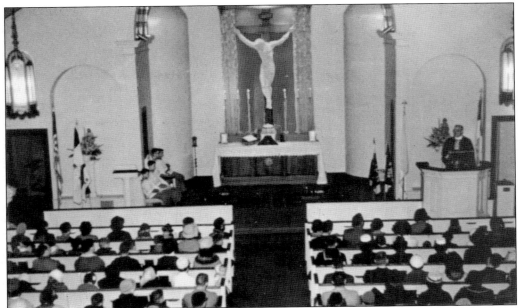

ST. NICHOLAS INTERIOR. The most prominent interior feature of St. Nicholas Church is the massive crucifix sculpted by Felix de Weldon, who also sculpted the Iwo Jima Memorial. De Weldon was serving as a painters mate first class at NAS Patuxent River when the now-famous photograph of the raising of the flag at Iwo Jima arrived by wire. Recognizing the power of the image, he abandoned his weekend leave to sculpt the first model of the massive statue that now sits outside the gates of Arlington National Cemetery.

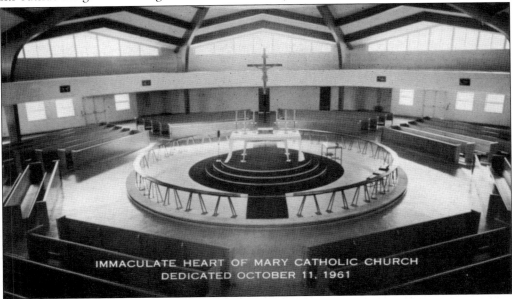

IMMACULATE HEART OF MARY CATHOLIC CHURCH
DEDICATED OCTOBER 11, 1961

IMMACULATE HEART OF MARY CATHOLIC CHURCH. Established in 1947, Immaculate Heart of Mary Church was constructed to serve former parishioners of St. Nicholas Church, which had been converted into the base chapel at NAS Patuxent River in 1943. A small, wood-frame church was replaced by a modern church in the round in 1961.

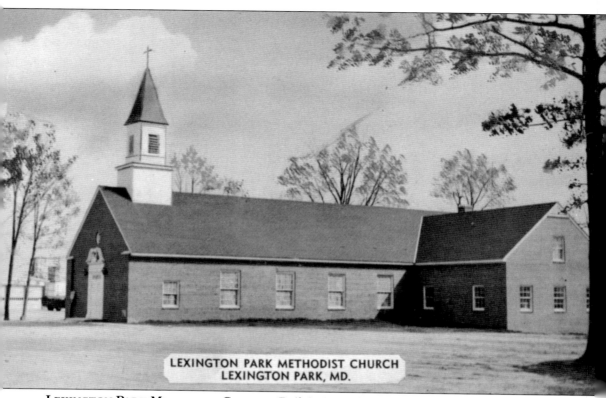

LEXINGTON PARK METHODIST CHURCH
LEXINGTON PARK, MD.

LEXINGTON PARK METHODIST CHURCH. Built in 1952, the Lexington Park Methodist Church was the successor to Ebenezer Methodist Episcopal Chapel, the mother church of Methodism in St. Mary's County. Ebenezer's congregation merged with the congregation from Cedar Point Methodist Episcopal Church, which had been displaced when NAS Patuxent River was constructed in 1943. Following a merger of splintered Methodist factions in 1968, the church changed its name to the Lexington Park United Methodist Church.

Three

SCHOOLS

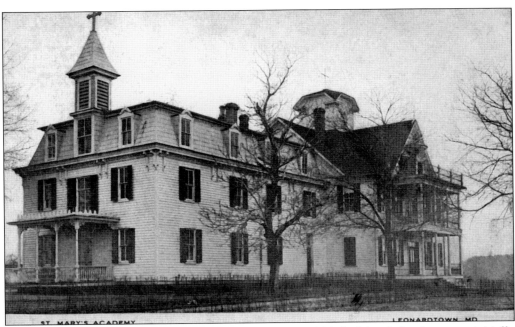

ST. MARY'S ACADEMY. Established in Leonardtown in 1885, St. Mary's Academy was initially a kindergarten–through–12th grade coeducational boarding school. In 1954, primary students transferred to the new Fr. Andrew White School. Male secondary students transferred to the new Ryken High School two years later. In 1981, the academy merged with Ryken to form St. Mary's Ryken, a coeducational high school. (Courtesy of St. Mary's County Historical Society.)

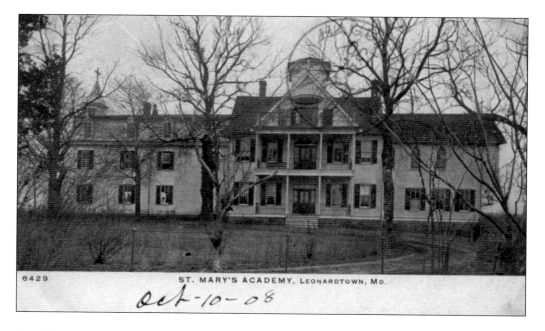

6429 ST. MARY'S ACADEMY, LEONARDTOWN, MD.

Oct-10-08

THE FIRST ACADEMY. In 1884, Col. Richard Miles and his wife, Mary Blades Miles, donated the James T. Blakistone house, located in Leonardtown on Rose Hill Farm, to Fr. Charles Jenkins, pastor of St. Aloysius Church, with the instruction that the property be used for a Catholic school. Many religious orders visited the site but declined to start a school because of the house's dilapidated condition. The Sisters of Charity of Nazareth, the 12th order to be consulted, agreed to open a school. Pictured above in 1908, the original house had been expanded 12 years before by the addition of dormitories and a dining hall at the rear of the structure.

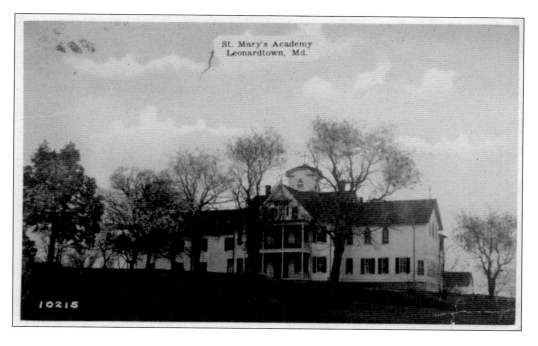

St. Mary's Academy
Leonardtown, Md.

10215

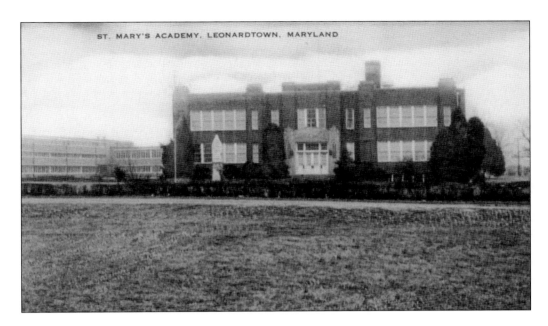

ST. MARY'S ACADEMY, LEONARDTOWN, MARYLAND

THE NEW ACADEMY. After the Blakistone house was demolished, the academy was moved to a frame structure. Construction of a new brick building began during the school's golden jubilee in 1935. The building, dedicated in April 1937, contained a library, auditorium, gymnasium, cafeteria, and nine classrooms. The old frame building continued to be used as a chapel, music room, and dormitories. In 1958, a cruciform brick dormitory, convent, and chapel was constructed. The academy closed its boarding facilities in 1974 and merged with Ryken High School in 1981. The property was subsequently converted into the Leonardtown location of Charles County Community College, now known as the College of Southern Maryland.

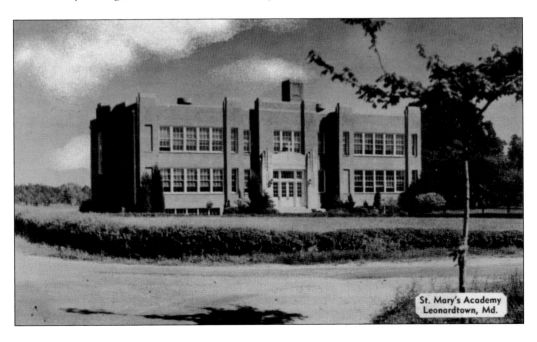

St. Mary's Academy
Leonardtown, Md.

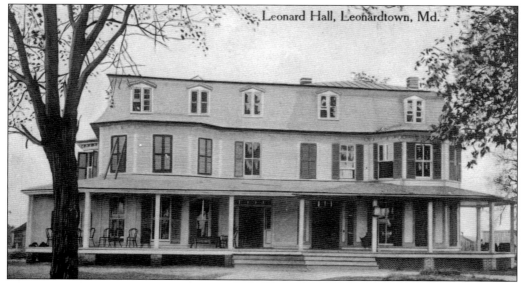

Leonard Hall, Leonardtown, Md.

LEONARD HALL. Named in honor of Maryland's first proprietary governor, Leonard Calvert, Leonard Hall opened in September 1909 as the first Catholic school for boys in St. Mary's County. The school was operated by the Xaverian Brothers, who taught agricultural courses to both local and boarding students. The classroom and dormitory building was destroyed by fire in 1920; a year later, the brothers' residence, the former home of William Mervell Loker known as Thornley, also succumbed to fire.

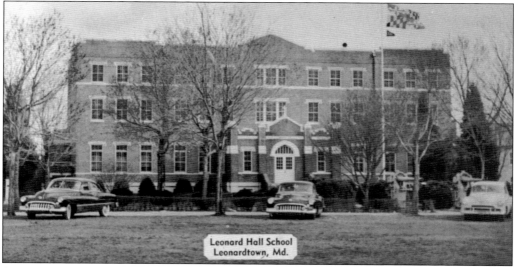

Leonard Hall School
Leonardtown, Md.

LEONARD HALL CHANGES WITH THE TIMES. Soon after fire destroyed Leonard Hall's classroom and dormitory building, a three-story brick administration building was constructed to house offices, clubs, and a dormitory. Over time, the school's curriculum changed from an agricultural program to college preparatory courses, elementary classes, and ultimately to a junior naval school. In 1972, the Xaverian Brothers announced they could no longer staff the school. Parents banded together and formed a nondenominational governing board to continue operating the school. The school's administration building, pictured here, is currently owned by the St. Mary's County government and used for offices.

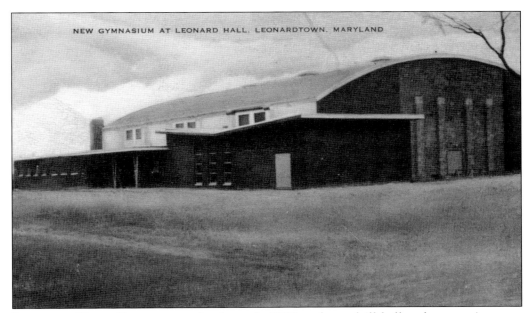

NEW GYMNASIUM AT LEONARD HALL, LEONARDTOWN, MARYLAND

LEONARD HALL GYMNASIUM. In the early 1960s, a large drill hall and gymnasium was constructed to provide space for sporting events and practicing military drills. The many hours of drilling paid off, and Leonard Hall students were honored to march in every presidential inaugural parade from 1949 to 1977.

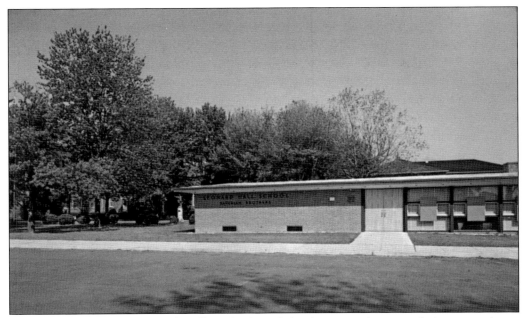

THE NEW SCHOOL. Leonard Hall Junior Naval Academy continues to thrive as a private, nondenominational, Christian, coeducational, military, college-preparatory school for grades six through twelve. The school occupies an octagonal building constructed in 1967 that contains eight classrooms and a library.

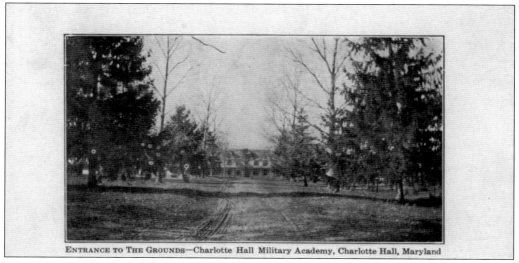

ENTRANCE TO THE GROUNDS—Charlotte Hall Military Academy, Charlotte Hall, Maryland

ENTRANCE TO CHARLOTTE HALL MILITARY ACADEMY. Charlotte Hall School was established by act of the Maryland General Assembly in April 1774 to provide a unified free school for the counties of Charles, St. Mary's, and Prince George's. The school was named after Queen Charlotte, the wife of Great Britain's King George III. Due to disruption caused by the Revolutionary War, Charlotte Hall School did not enroll its first students until 1796. In 1852, the school adopted a military curriculum and changed its name to the Charlotte Hall Military Academy.

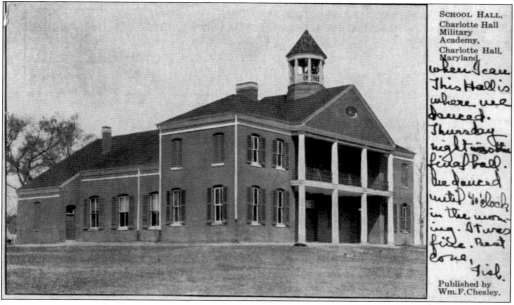

SCHOOL HALL,
Charlotte Hall
Military
Academy,
Charlotte Hall,
Maryland

*when I can
This Hall is
where we
danced.
Thursday
night was the
final ball.
We danced
until 4 o'clock
in the morn-
ing. It was
fine. Best
come,
Fish.*

Published by
Wm. F. Chesley.

SCHOOL HALL. Charlotte Hall Military Academy was recognized as one of the finest military academies in the country. Alumni and trustees included Roger Brooke Taney, fifth chief judge of the US Supreme Court; Rev. Thomas John Claggett, the first Episcopal bishop consecrated in America; George Watterson, the first librarian of Congress; Edward Bates, attorney general during the Lincoln administration; and Maryland governors Robert Bowie, Thomas King Carroll, and James Thomas. Actor Sylvester Stallone attended the school for one year, but he reportedly did not enjoy his time there.

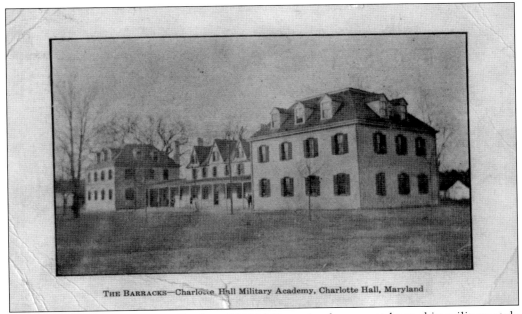

THE BARRACKS—Charlotte Hall Military Academy, Charlotte Hall, Maryland

THE BARRACKS. Students at Charlotte Hall Military Academy were housed in military-style barracks. Pictured here in 1918, the barracks were completely destroyed by a fire in 1924 that started during the school's midwinter dance. Alarms were sent as far as Washington, DC, but the fire departments arrived too late to save the barracks.

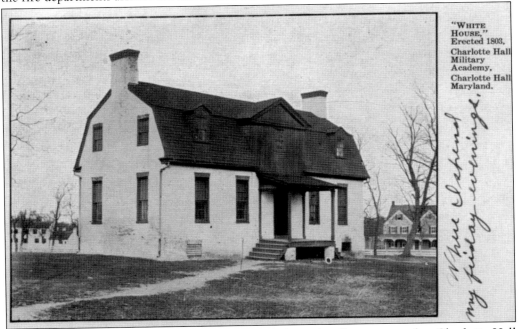

"WHITE HOUSE," Erected 1803, Charlotte Hall Military Academy, Charlotte Hall Maryland.

THE WHITE HOUSE. The White House was the first schoolhouse erected at Charlotte Hall School. It was constructed in 1803 as both a classroom building and dormitory. It later served as a residence for the school president as well as a meeting place for the Washington and Stonewall Literary Society and the school's board of trustees.

45

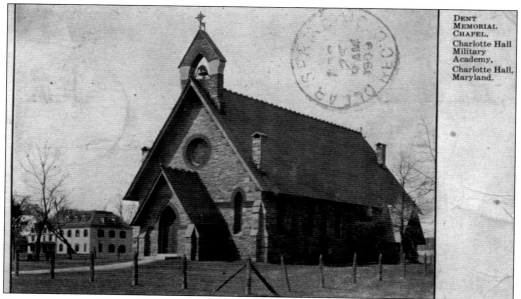

DENT MEMORIAL CHAPEL, Charlotte Hall Military Academy, Charlotte Hall, Maryland.

DENT CHAPEL. When Charlotte Hall School was chartered in 1774, the trustees decreed the headmaster should be the rector of All Faith Episcopal Church located nearby in the town of Charlotte Hall. In 1883, Dent Memorial Chapel was built in memory of the school's first headmaster, Rev. Hatch Dent, a member of the Maryland 400 taken prisoner by the British during the Revolutionary War's Battle of Brooklyn and later an Episcopalian priest.

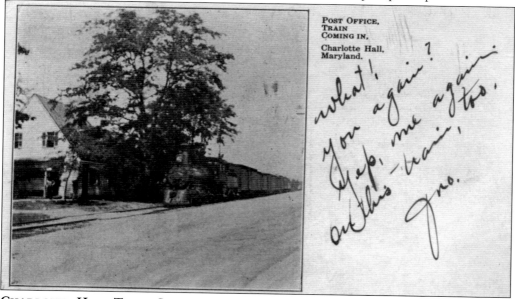

POST OFFICE, TRAIN COMING IN, Charlotte Hall, Maryland.

CHARLOTTE HALL TRAIN STATION AND POST OFFICE. During the school's heyday, many students arrived by train. The Washington City and Point Lookout Railroad began rail service to Charlotte Hall in 1881. A succession of financially unstable rail lines operated the route until the federal government took over operations in 1942. By the mid-1960s, the line was used only for occasional fuel shipments to NAS Patuxent River. Today, the old railroad right-of-way is a community trail known as Three Notch Trail.

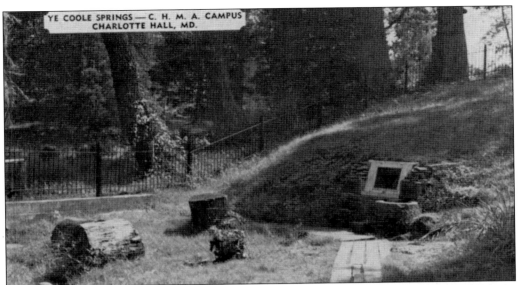

Ye Coole Springs. Before European settlers arrived in Maryland, Native Americans visited a freshwater spring located in Charlotte Hall because the water purportedly had curative powers. In 1697–1698, after a severe bout of pestilence struck Southern Maryland, Maryland's royal governor issued a proclamation of thanksgiving for the healing spring and recommended the construction of a hospital nearby. A sanitarium, thought to be the first in English-speaking North America, was subsequently constructed.

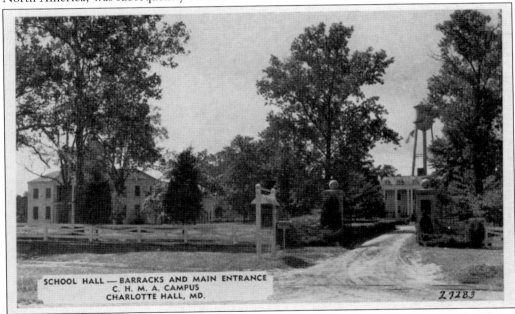

The Campus Changes. This image, from the early 1960s, shows Charlotte Hall Military Academy's old school hall and the new barracks built in 1960. In 1968, the Maryland legislature enacted a law phasing out scholarship funding for the school. The school began accepting female day students in 1972, and the military program became optional in 1974. In June 1976, after years of financial difficulties, the school closed. The grounds are presently used as a veterans' home.

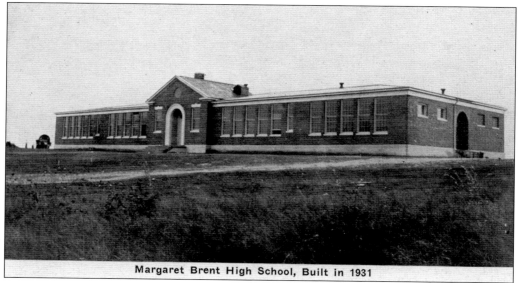

Margaret Brent High School, Built in 1931

MARGARET BRENT HIGH SCHOOL. Located in Helen, Margaret Brent High School was constructed in 1931 to serve public school students in northern St. Mary's County. Its namesake, Margaret Brent, was one of the most prominent women in Colonial America, serving as a respected advisor of the first proprietary governor of Maryland, Leonard Calvert, and demanding a vote and "voyce" in the general assembly. The school was converted to a middle school in 1965 when Chopticon High School opened. (Courtesy of St. Mary's County Historical Society.)

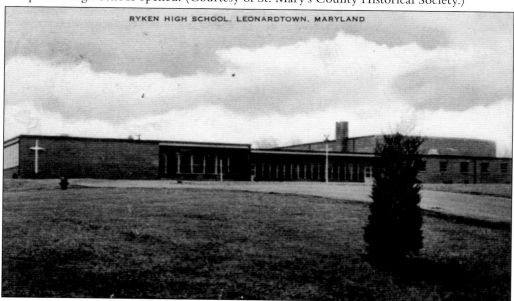

RYKEN HIGH SCHOOL. LEONARDTOWN. MARYLAND

RYKEN HIGH SCHOOL. In 1956, the Xaverian Brothers begin construction of a juniorate and high school on the grounds of Camp Calvert overlooking Leonardtown's Breton Bay. Classes began before construction was completed, so the brothers were forced to live in the camp's cabins. During winter, the plumbing froze, forcing the brothers to use shower facilities at NAS Patuxent River, located 12 miles away. The nearly completed school opened for students on February 25, 1957. (Courtesy of George A. Kirby III.)

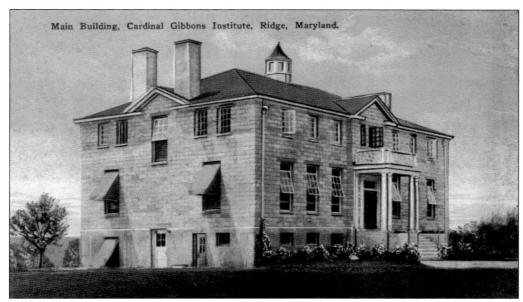

Main Building, Cardinal Gibbons Institute, Ridge, Maryland.

CARDINAL GIBBONS INSTITUTE. The Cardinal Gibbons Institute was St. Mary's County's first high school serving African Americans. Opened in September 1924, it was located near St. Peter Claver Catholic Church in Ridge. Except for a few years during the Great Depression, the school provided academic, vocational, and religious education to African Americans until desegregation occurred in the late 1960s. The building was torn down in 1972, and a memorial was erected in 1990

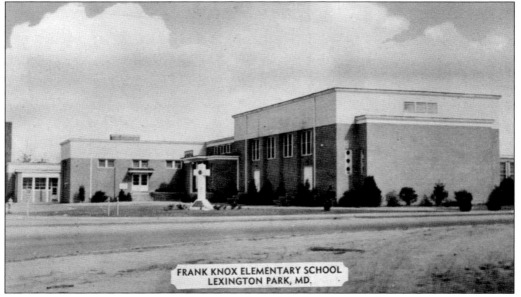

FRANK KNOX ELEMENTARY SCHOOL
LEXINGTON PARK, MD.

FRANK KNOX SCHOOL. Located next to the original main gate for NAS Patuxent River, Frank Knox School was constructed in 1944 for the children of the base's civilian and military personnel. It was named for William Franklin Knox, who served as the secretary of the Navy for most of World War II. The school closed in 1989, and the building subsequently has been used as a security office and adult education center.

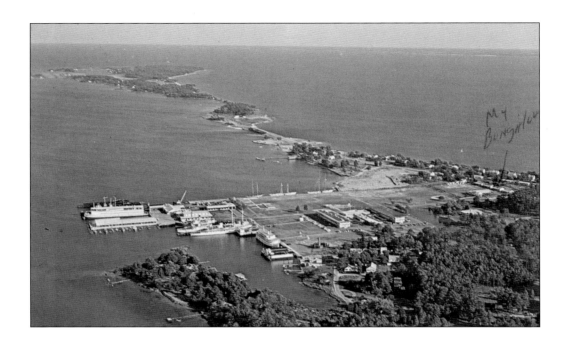

HARRY LUNDEBERG SCHOOL OF SEAMANSHIP. The Harry Lundeberg School of Seamanship, affiliated with the Seafarers International Union, is a two-year college established in 1967 to prepare students for careers as US merchant mariners. Located on a picturesque 70-acre campus on the banks of St. George's Creek in Piney Point, the school offers associate of applied science degrees and certificates in nautical science and marine engineering.

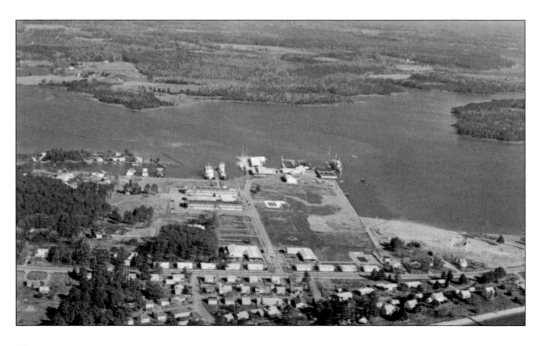

Four

ST. MARY'S COLLEGE

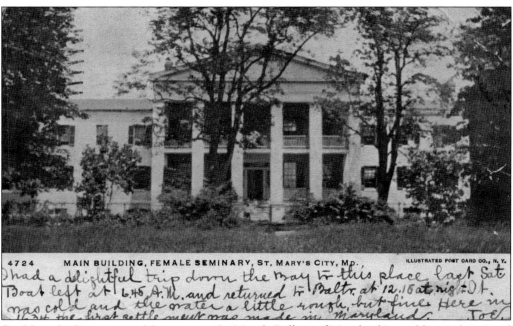

4724 MAIN BUILDING, FEMALE SEMINARY, ST. MARY'S CITY, MD. ILLUSTRATED POST CARD CO., N. Y.

I had a delightful trip down the bay to this place last Sat. Boat left at 6.45 A.M. and returned to Balt. at 12.15 at night. It was cold and the water a little rough, but fine. Here in 1634 the first settlement was made in Maryland. Joe.

ST. MARY'S COLLEGE OF MARYLAND. St. Mary's College of Maryland is a public coeducational liberal arts college located on the banks of the St. Mary's River in historic St. Mary's City. It traces its roots to the St. Mary's Female Seminary, which was established in 1840 as a living monument to the history and ideals of St. Mary's City. The college is Maryland's only public honors college, and it is consistently ranked as one of the top public liberal arts colleges in the nation. This image shows the main building before it was destroyed by a fire in 1924.

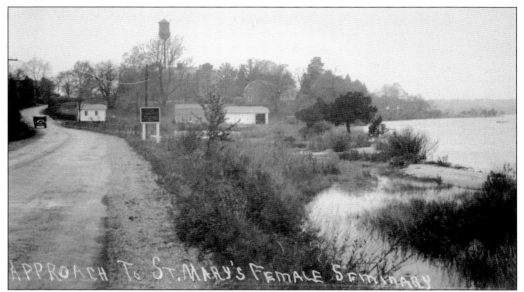

APPROACH TO ST. MARY'S FEMALE SEMINARY. In this 1920s view of the approach to the St. Mary's Female Seminary, the St. Mary's River comes within only a few feet of State Route 5. Church Point appears on the right, and the main building and water tower are located on the horizon. Today, the water tower has been removed and the sandy area on the right, now augmented by fill, is occupied by the James P. Muldoon River Center and Rowing Center. (Courtesy of St. Mary's College of Maryland Archives.)

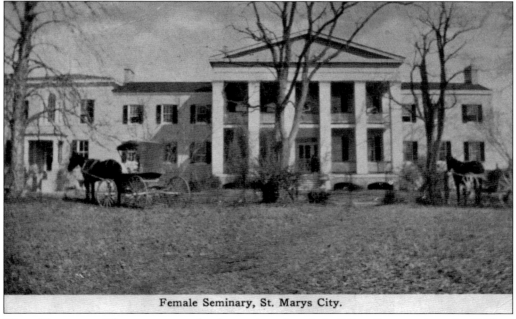

Female Seminary, St. Marys City.

MAIN BUILDING. The cornerstone for the seminary's main building (known since the 1960s as Calvert Hall) was laid in 1842, and students began classes in 1846. At that time, the only other building on campus was a brick stable, which reportedly was constructed using bricks from the 1676 statehouse. This image shows a rare glimpse of a portico on the main building's west wing.

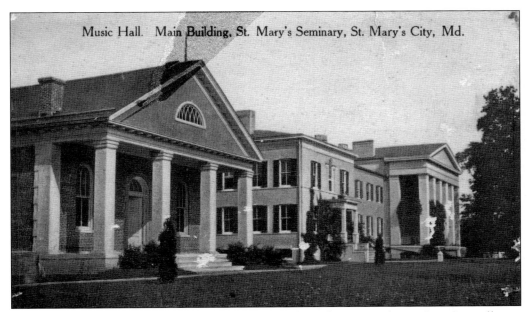

Music Hall. Main Building, St. Mary's Seminary, St. Mary's City, Md.

MUSIC HALL AND MAIN BUILDING. By the turn of the 20th century, the seminary's enrollment was about 40 students. In 1926, a junior college division was added to the curriculum, and the school's name changed to St. Mary's Female Seminary-Junior College. As the school's principal, M. Adele France, explains in her 1925 handbook, "The time is past when we educated our daughters for ornaments only."

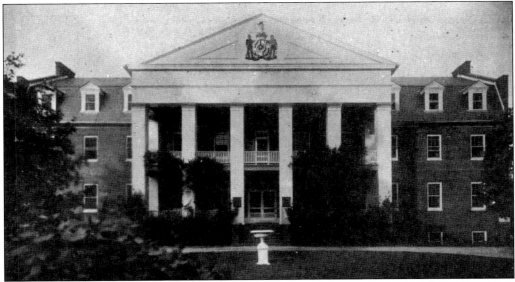

RECONSTRUCTION OF THE MAIN BUILDING. On January 5, 1924, a fire destroyed the main building while school was closed for the Christmas holidays. Students and faculty were housed in temporary wooden barracks until a new main building was completed in June 1925. The new edifice, pictured here, included an additional floor. The structure is currently used for administrative offices, archives, and two floors or student dormitories. (Courtesy of St. Mary's College of Maryland Archives.)

MAIN BUILDING — A HOSPITABLE SETTING FOR CLASSES,
ADMINISTRATIVE OFFICES AND DORMITORY LIFE

MAIN BUILDING BALCONY. This image shows a detailed view of the main building's two-story balcony, which provides an expansive view of the Trinity Church grounds and the St. Mary's River. The Calvert family seal, which is also the state seal of Maryland, is displayed above the balcony.

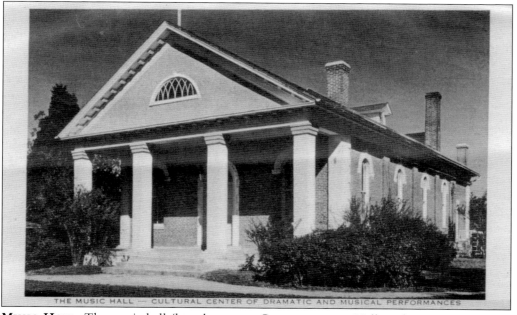

THE MUSIC HALL — CULTURAL CENTER OF DRAMATIC AND MUSICAL PERFORMANCES

MUSIC HALL. The music hall (later known as Commencement Hall or the gymnasium) was constructed in 1908. It is the oldest building on campus, having survived the 1924 fire that destroyed the main building. Today, the music hall is known as St. Mary's Hall.

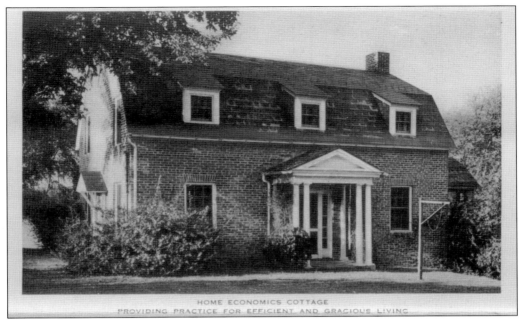

HOME ECONOMICS COTTAGE
PROVIDING PRACTICE FOR EFFICIENT AND GRACIOUS LIVING

HOME ECONOMICS COTTAGE. Originally a brick stable, this structure was transformed in 1924 into a cottage using bricks from the burned-out main building. The cottage was used as a home economics laboratory and, beginning in 1955, the residence for school president May Russell. The cottage is currently used as an alumni lodge named in honor of President Russell.

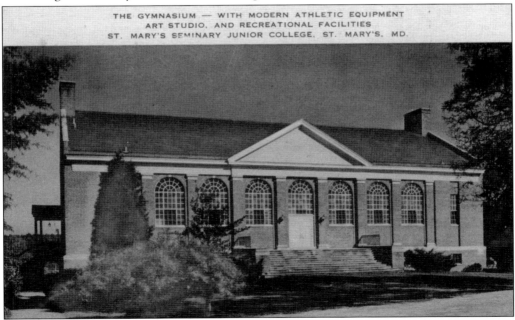

THE GYMNASIUM — WITH MODERN ATHLETIC EQUIPMENT
ART STUDIO, AND RECREATIONAL FACILITIES
ST. MARY'S SEMINARY JUNIOR COLLEGE, ST. MARY'S, MD.

GYMNASIUM AND ART STUDIOS. To celebrate the college's 100th anniversary, the State of Maryland built a two-story gymnasium, art studio, and recreational facility in 1941. Later named Kent Hall, the building was gutted in 1998 and repurposed as a science building. Today, the structure is used for history and social science classes.

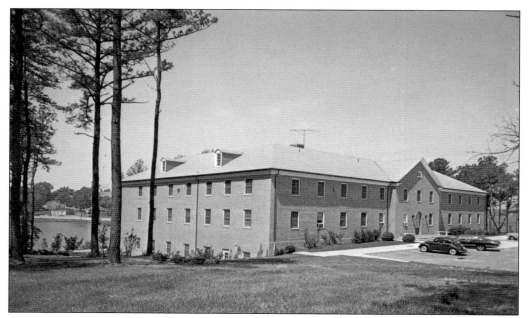

QUEEN ANNE HALL. Built in 1965, Queen Anne Hall overlooks St. John's Pond and the St. Mary's River. It currently serves as the college's only all-female residence hall and houses 154 students.

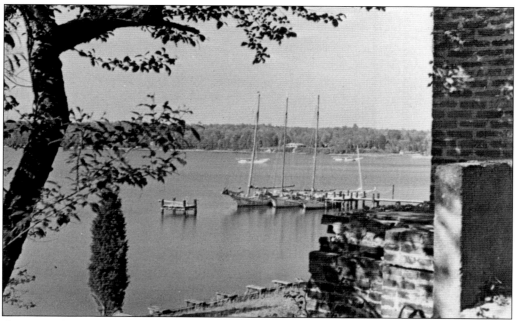

COLLEGE PIER. Given the college's waterfront location, sailing and other water sports have always been popular among students. In 1962, the college offered sailing as a physical education class and added a varsity sailing program in 1980. Since that time, the college has captured 15 national sailing titles, and almost 150 of the college's sailors have been named All-Americans.

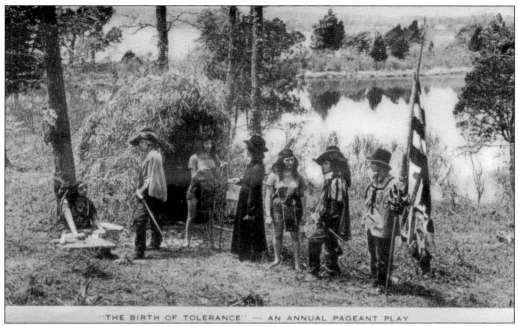

"THE BIRTH OF TOLERANCE" — AN ANNUAL PAGEANT PLAY

ANNUAL PAGEANT. Between 1950 and 1959, students from the college, then known as St. Mary's Seminary Junior College, performed a three-day annual history pageant known as *The Birth of Tolerance*. Every student was assigned a role. The audience included schoolchildren, participants in a home and garden tour from Baltimore, and members of the public. Scenes took place in St. Mary's Hall, Calvert Hall, the statehouse, and Church Point.

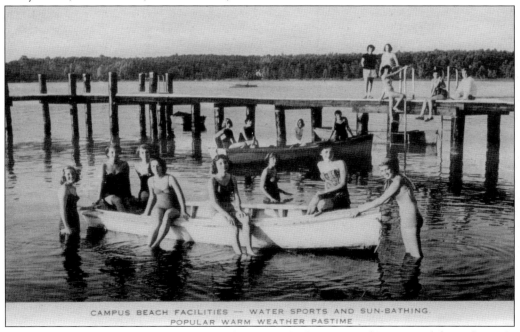

CAMPUS BEACH FACILITIES — WATER SPORTS AND SUN-BATHING.
POPULAR WARM WEATHER PASTIME

SUNBATHING ON THE SHORES OF THE ST. MARY'S RIVER. In this postcard from the early 1950s, students relax on the school pier while improving their suntans.

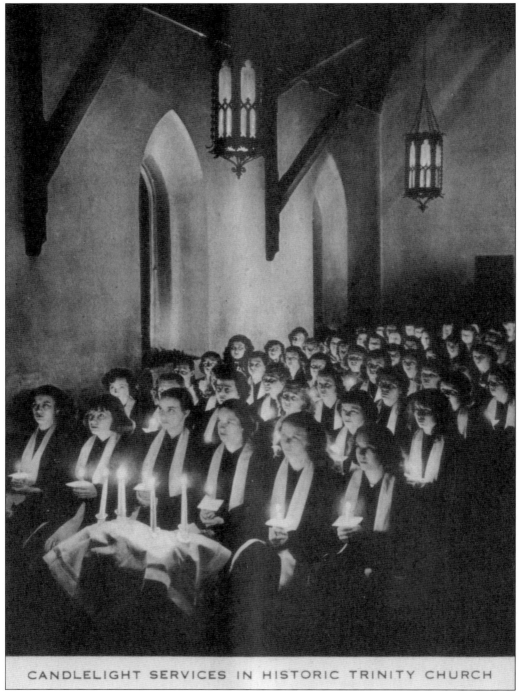

CANDLELIGHT SERVICES IN HISTORIC TRINITY CHURCH

CANDLELIGHT SERVICES IN TRINITY CHURCH. The college was founded to promote the ideal of religious toleration. Its charter prohibited proselytizing, and its board of trustees traditionally included denominational seats held by Catholic, Episcopalian, and Methodist members. In the college's early days, students were required to attend their own churches on Sundays.

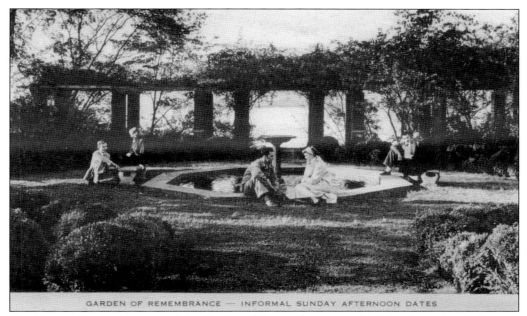

GARDEN OF REMEMBRANCE — INFORMAL SUNDAY AFTERNOON DATES

GARDEN OF REMEMBRANCE. The Garden of Remembrance was built by the college's alumnae association in honor of Maryland's tercentennial. It was designed by the University of Maryland's Mark Shoemaker at a cost of $190.30. The pergola located on the garden's waterside was donated by the Daughters of the American Revolution.

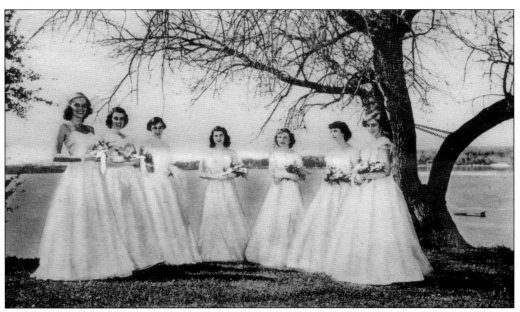

MAY QUEEN AND HER COURT. May Day celebrations have long been a tradition at the college. Until the early 1970s, the college held an annual May Day pageant, including a procession of the May Court, crowning of the May Queen, and modern dance performances. At the turn of the 21st century, students celebrated spring by participating in a May Day naked run. After this event garnered national attention, the exact date, time, and location of the annual run is kept secret.

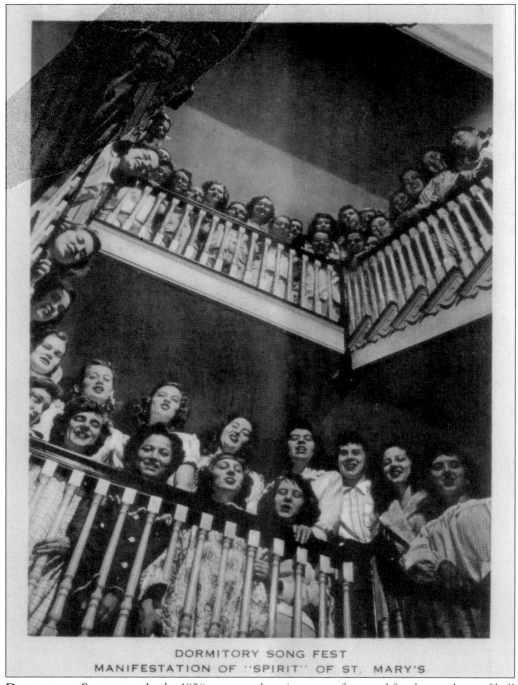

DORMITORY SONG FEST
MANIFESTATION OF "SPIRIT" OF ST. MARY'S

DORMITORY SONGFEST. In the 1950s, proms, dormitory songfests, and faculty–student softball games were popular extracurricular activities. This main staircase in Calvert Hall still leads to dormitory rooms.

Five

HOTELS

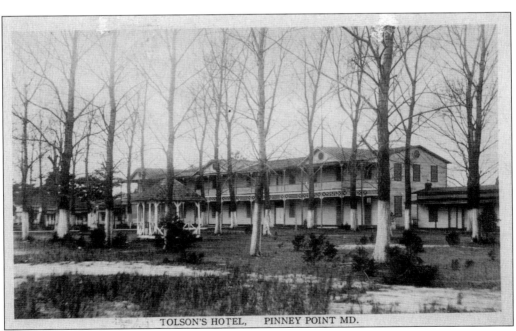

TOLSON'S HOTEL, PINNEY POINT MD.

PINEY POINT HOTEL. For nearly 200 years, St. Mary's County was a favorite summer escape for people from Washington, DC, and Baltimore. Resort hotels built along the Chesapeake Bay and the Potomac and Patuxent Rivers offered city folks outdoor recreation, delicious seafood, and cooling breezes.

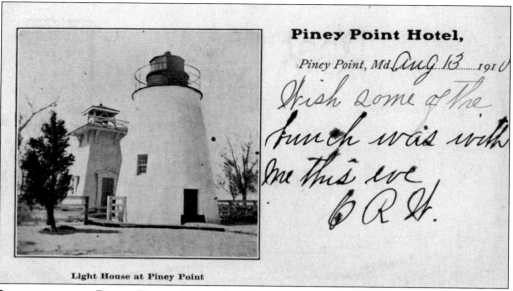

Piney Point Hotel,

Piney Point, Md. Aug 13 1910

Wish some of the
bunch was with
me this eve
6 R A.

Light House at Piney Point

LIGHTHOUSE AT PINEY POINT. When the Piney Point Lighthouse came into view from the deck of a steamship, summer visitors knew they were near their destination. The beacon was constructed in 1836 by John Donahoo, a renowned lighthouse builder, for $3,888. It still stands 35 feet high, with walls nearly four feet thick at the base.

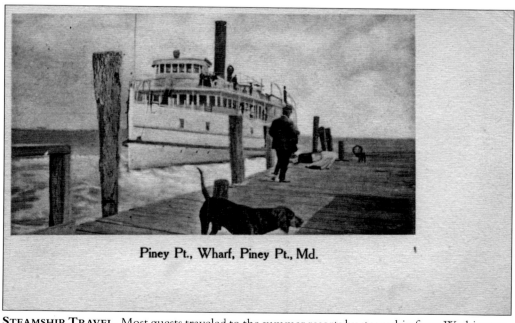

Piney Pt., Wharf, Piney Pt., Md.

STEAMSHIP TRAVEL. Most guests traveled to the summer resorts by steamship from Washington, DC, and Baltimore. In this image from the early 1900s, a steamship departs Piney Point Wharf, watched closely by a gentlemen and a hound.

62

Piney Point Hotel,

Piney Point, Md., _Aug. 17___ 191_

[handwritten message]

Piney Point Landing

PINEY POINT WHARF. When guests arrived at the Piney Point Hotel, they disembarked onto a long, wooden wharf extending into the Potomac River. Valets greeted the guests and helped carry their luggage up the hill to the main building.

Piney Point Hotel,

Piney Point, Md., _Aug. 9___ 1912

_Think this
is a very
pretty place
Had a dandy
time Tuesday.
Best wishes_

Piney Point Hotel

FRONT LAWN OF THE PINEY POINT HOTEL. A hotel was first constructed on the Potomac shore at Piney Point around 1838. Originally known as the Piney Point Pavilion, the hotel entertained numerous presidents and other dignitaries, including James Monroe, Franklin Pierce, Theodore Roosevelt, Daniel Webster, Henry Clay, and John C. Calhoun.

Piney Point Hotel,

Piney Point, Md., *July 23rd 1910*

Friend Ruth
This is certainly a
dandy place to have a
good time as their is
a good jolly bunch
here, and plenty of
all kinds of sport
having as good a time
hope you are enjoying your as much as I am Harry

On the Lake at Piney Point

THE LAKE AT PINEY POINT. The lake at Piney Point, in reality a branch of Piney Point Creek located north of the hotel, provided a safe and shallow boating venue for children and the fairer sex. In 1888, the hotel advertised a "fleet of rowboats for the accommodation of ladies." Gentlemen apparently engaged in other pastimes.

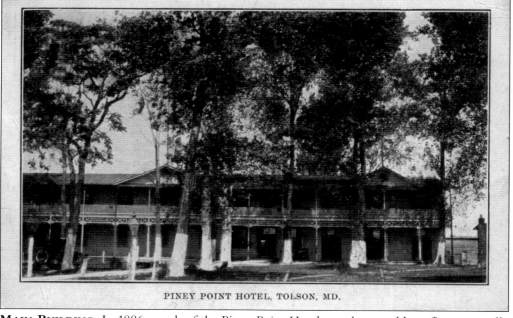

PINEY POINT HOTEL, TOLSON, MD.

MAIN BUILDING. In 1886, much of the Piney Point Hotel was destroyed by a fire reportedly started by an arsonist. The hotel was vacant for period of time until Warren Tolson purchased the property in 1905. He would operate the hotel for the next 38 years. During Tolson's ownership, the property consisted of a large hotel building, barroom, barbershop, dining room, kitchen, dance pavilion, and 27 cottages.

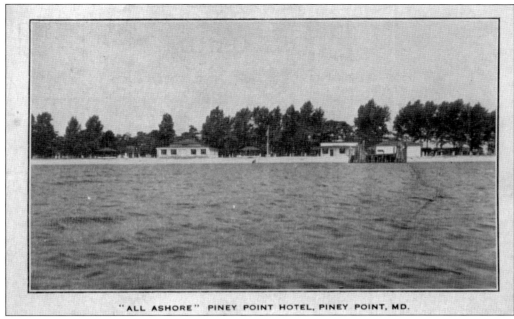

"ALL ASHORE" PINEY POINT HOTEL, PINEY POINT, MD.

POTOMAC WATERFRONT AT PINEY POINT. During the Great Depression, the Piney Point Hotel remained open, but business suffered. In August 1933, the hotel was severely damaged by a hurricane, which destroyed the wharf and washed away many of the cottages. Between 1943 and 1950, personnel from NAS Patuxent River occupied the hotel. It was later demolished, and the property is currently divided into lots awaiting construction of private homes.

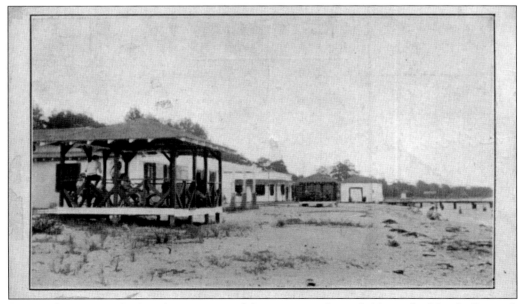

BEACH PAVILIONS. Swimming was one of the most popular activities at St. Mary's County's summer resorts. On the broad beach at Piney Point, bathing gazebos were constructed to protect guests from excessive sun. Other activities at summer resorts included fishing, crabbing, yachting, bowling, billiards, quoits, shooting, and dancing.

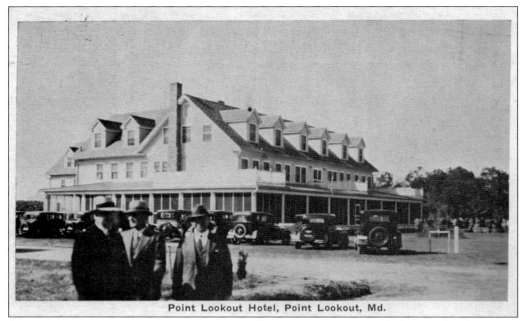

Point Lookout Hotel, Point Lookout, Md.

POINT LOOKOUT HOTEL. Congressman William Cost Johnson built the first hotel at Point Lookout in 1857. The hostelry included a two-story frame structure, a steamboat wharf, and approximately 100 summer cottages. During the Civil War, the hotel was converted into a Union military hospital. The building was destroyed by a fire in 1878. A new hotel, pictured here, was built in 1929.

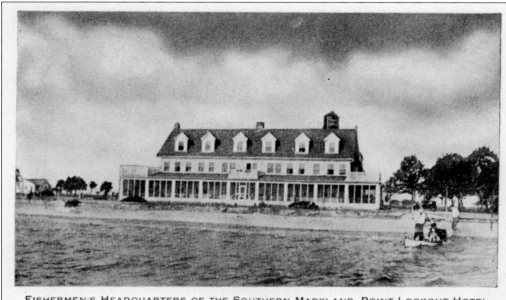

FISHERMEN'S HEADQUARTERS OF THE SOUTHERN MARYLAND. POINT LOOKOUT HOTEL. POINT LOOKOUT, MD.

CHESAPEAKE BAY SHORELINE. The Point Lookout Hotel was located steps away from the Chesapeake Bay. The hotel had 47 guest rooms, 27 baths, and three servants' rooms. Amenities included a dining room, lounge, pools, bathhouse, tennis courts, beach, and pier.

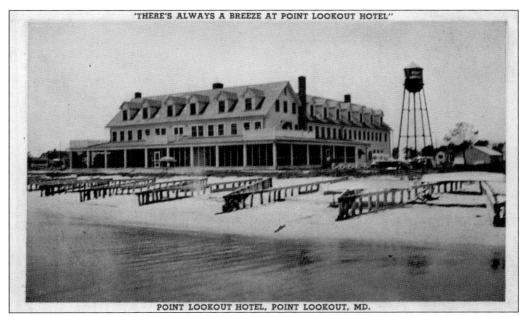

'THERE'S ALWAYS A BREEZE AT POINT LOOKOUT HOTEL"

POINT LOOKOUT HOTEL, POINT LOOKOUT, MD.

BATTLING SHORELINE EROSION. Like many properties located on the Chesapeake Bay, the Point Lookout Hotel property experienced significant shoreline erosion. This image, taken around 1941, shows V-shaped seawalls installed to preserve the beach.

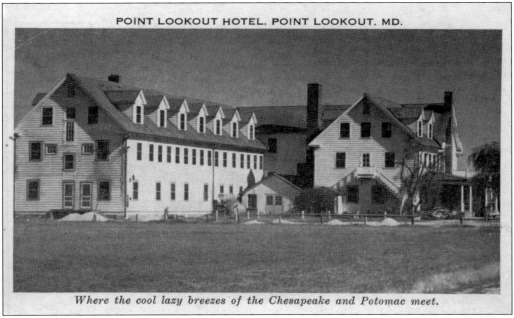

POINT LOOKOUT HOTEL. POINT LOOKOUT. MD.

Where the cool lazy breezes of the Chesapeake and Potomac meet.

WANING DAYS OF A ONCE-POPULAR RESORT. By the 1930s, the Point Lookout Hotel had fallen on hard times because steamboats no longer stopped at the hotel's wharf. After World War II, the hotel had a succession of managers and, at one point, was operated as a recreational facility by a branch of the US Army. The building was unoccupied by the 1970s and demolished in September 1989.

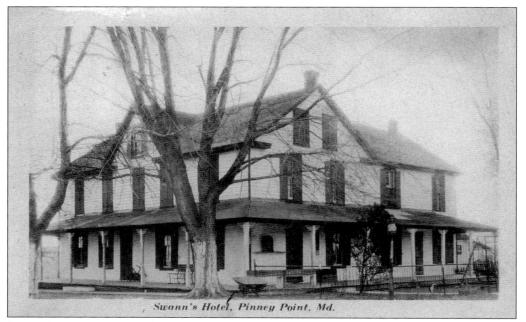

SWANN'S HOTEL. Around 1885, schooner captain James Thomas Swann and his wife, Alice, opened a general store in Piney Point on the banks of St. George's Creek. Around 1912, the Swanns began accepting summer boarders into their home. The Swann family would run the hotel continuously for more than 50 years.

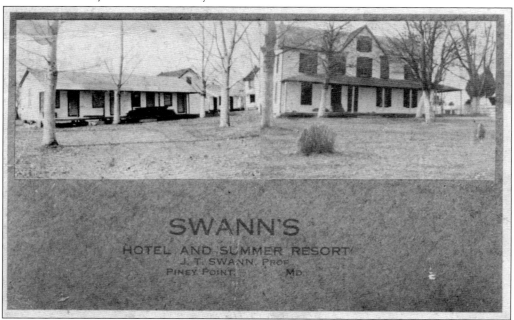

MAIN BUILDING AND CABINS. Originally constructed as a private home, Swann's Hotel was built around 1900. After remodeling, it contained 40 rooms. In the 1920s, B. Gorman Swann added a series of rustic, one-room bungalows. The bungalows lacked plumbing, so each guest was provided with a slop jar.

68

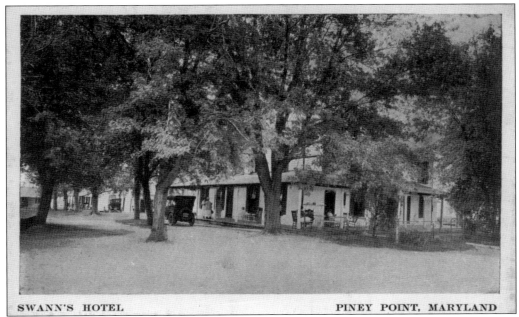

SWANN'S HOTEL PINEY POINT, MARYLAND

COOL BREEZES ON THE LONG PORCH. The day began at Swann's Hotel when "Aunt Lizzie," one of the hotel's employees, rang the rising bell. Breakfast was served at 8:00 a.m. and consisted of fried fish, hot rolls, corn bread, home fries, bacon, and eggs. The main meal was served at noon, and afterwards guests retreated to the long porch for a nap or game of cards.

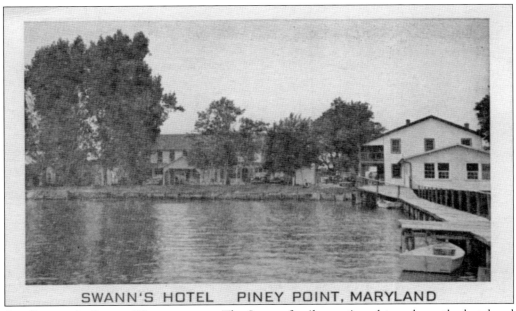

SWANN'S HOTEL PINEY POINT, MARYLAND

ST. GEORGE'S CREEK WATERFRONT. The Swann family continued to enlarge the hotel and store through the 1940s. The hotel business slowed in the 1960s, and the hotel was closed by 1970. The complex was extensively renovated and reopened in 1989 but has since been replaced by condominiums.

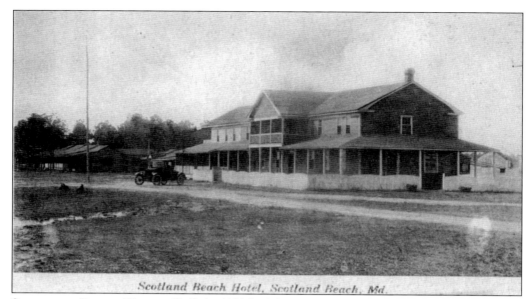

Scotland Beach Hotel, Scotland Beach, Md.

SCOTLAND BEACH HOTEL. Built in 1921 by Thomas A. Ridgell, the Scotland Beach Hotel had 36 rooms, a dance pavilion, a 100-foot pier, and a 35-foot-wide sand beach. Guests returned year after year to enjoy food served family-style by Ridgell's wife, Eulalia Tennyson Ridgell, including crab cakes, fried fish, chicken, biscuits, pies, cakes, and homemade ice cream. The hotel survived a hurricane in August 1933 but was destroyed by a fire in 1946. (Courtesy of St. Mary's County Historical Society.)

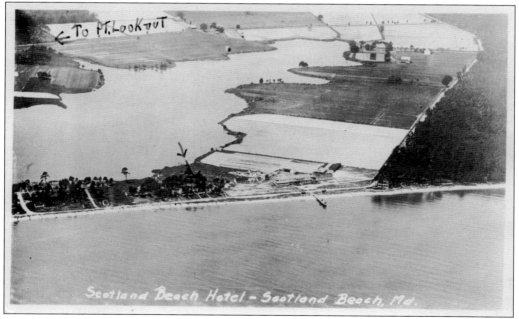

Scotland Beach Hotel – Scotland Beach, Md.

CHESAPEAKE SHORELINE. Pictured here in 1927, the Scotland Beach Hotel sat approximately 100 yards back from the Chesapeake Bay. A hurricane in 1933 greatly eroded the beach and destroyed an ineffective seawall. After subsequent storms and years of uncontrolled shoreline erosion, the site of the hotel now sits 200 feet offshore.

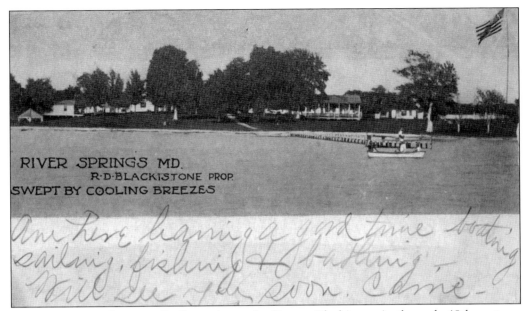

RIVER SPRINGS MD.
R·D·BLACKISTONE PROP.
SWEPT BY COOLING BREEZES

Are here having a good time boating, sailing, fishing & bathing — Will see you soon. Came —

RIVER SPRINGS RESORT. Built as a home for George Blackistone in the early 19th century, River Springs overlooks St. Catherine's Sound on the Potomac River. During the late 1800s, Blackistone's son Dr. Richard Pinkney Blackistone began lodging patients in the wings of his home. By 1898, he was operating the property as a summer resort that offered a "refined environment" and "cuisine unsurpassed." The resort closed in the 1930s and is a private residence today.

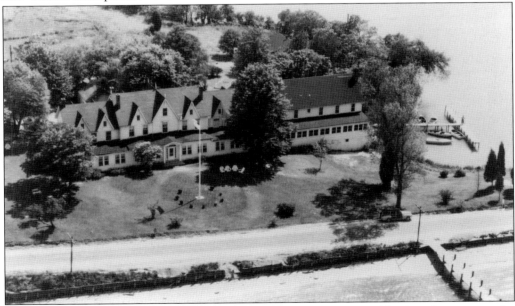

SEVEN GABLES HOTEL. Located at Spencer's Wharf, the Seven Gables Hotel was a popular fishing resort and reception venue. Owned by Ralph H. Blackistone, the hotel was a convenient place to cool off after a day of water-skiing and boat racing. In the 1950s, guests enjoyed $2 platters of soft crab sandwiches and 25¢ beers. The hotel closed in the 1970s and was torn down in 1990. Today, a boat storage facility and marina stand on the former hotel grounds.

GRAVES HOTEL CABINS. Until desegregation in the 1960s, African Americans were not permitted to stay at "whites only" resorts. In response, several African American entrepreneurs opened summer resorts. In 1913, John and Mary Golden purchased a 16-acre tract of land on St. Patrick's Creek near Colton's Point and began hosting boarders in their home. By 1915, they constructed the two-story Golden Hotel and later added an overwater dance pavilion, bar, cottages, and boat pier. In 1956, the property was sold to Harry and Mildred Graves. Harry was a teacher and basketball coach at Armstrong High School in Washington, DC. The Graves sold the hotel to Yale and Margaret Lewis in 1968. The facility closed in 1974 and was demolished in the early 2000s. (Courtesy of George A. Kirby III.)

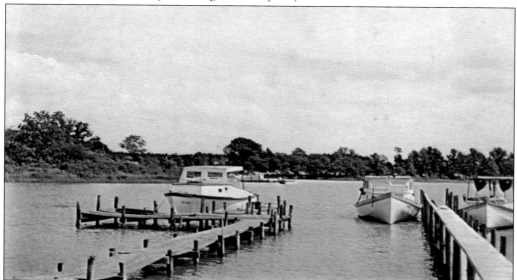

PIER AT GRAVES HOTEL. Postcards from the 1960s describe the Graves Hotel as a destination for the "Discriminating Vacationist." The hotel was a summer respite for well-heeled African American families, professional organizations, and church groups. Guests typically stayed by the week or month. Although the hotel had room for only 100 overnight guests, more than 300 people attended weekly dances that began at midnight and continued until dawn. The hotel offered swimming, outdoor sports, boating, and fishing parties, and guests dined on St. Mary's County's finest seafood, chicken, and fresh vegetables.

Six

SUMMER CAMPS

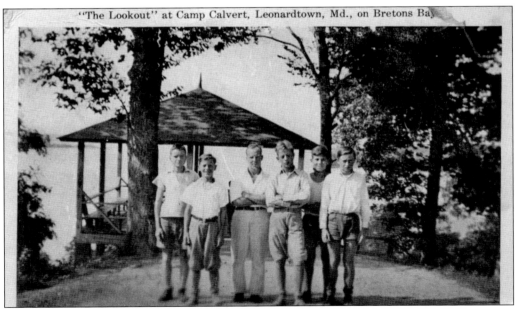

"The Lookout" at Camp Calvert, Leonardtown, Md., on Bretons Bay

A SUMMER PARADISE. In the days before air-conditioning, city children flocked to summer camps dotting the Chesapeake shoreline. St. Mary's County, which was readily accessible by steamboat and automobile, was the site of many popular camps sponsored by religious orders and civic organizations.

write more next time. I am going to take a swim now. I am haveing a good time.

Love. Write Soon from Earl, ask Dannie for the addres.

THE CAMP

CAMP WINSLOW. Built in the 1920s, Camp Winslow was operated by the Boys Club of Greater Washington, DC. Located in Dameron, the camp offered modest accommodations but beautiful views of the Chesapeake Bay.

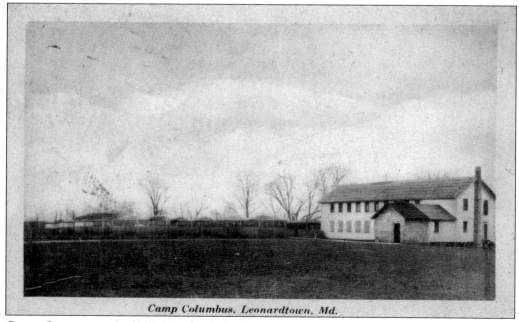

Camp Columbus, Leonardtown, Md.

CAMP COLUMBUS. In 1916, Enoch Abell sold the Xaverian Brothers a 100-acre parcel of land located in Leonardtown, on the shores of Breton Bay. During the 1920s and early 1930s, the brothers used the land for a summer camp for boys known as Camp Columbus. In 1933, the Xaverian Brothers changed the name of Camp Columbus to Camp Calvert.

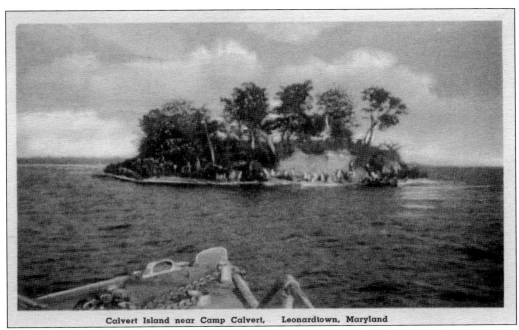

Calvert Island near Camp Calvert, Leonardtown, Maryland

CALVERT ISLAND. Camp Calvert offered boundless opportunity for adventure. Campers often visited Calvert Island, where the imaginations of young boys transformed the place into a pirates' lair or home for castaways. The island has apparently disappeared, the victim of erosion.

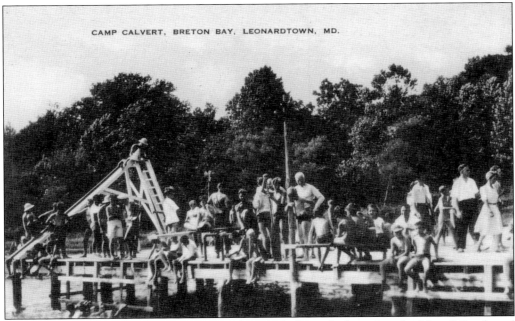

CAMP CALVERT, BRETON BAY, LEONARDTOWN, MD.

WHARF AND SWIMMING AREA. Camp Calvert had a large dock equipped with a sliding board and diving board. Brothers provided swimming and diving lessons, and even the most frightened nonswimmer would be coaxed into Breton Bay by the end of the summer.

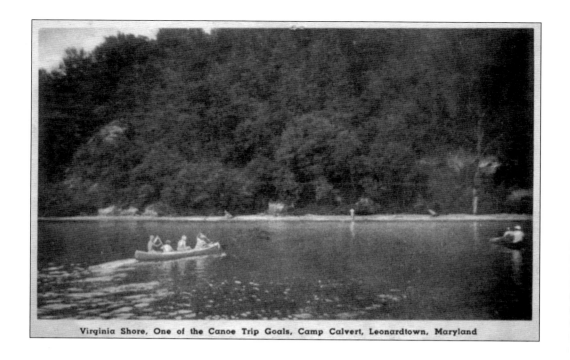

Virginia Shore, One of the Canoe Trip Goals, Camp Calvert, Leonardtown, Maryland

CANOEING ON BRETON BAY AND THE POTOMAC. Canoeing was one of the camp's most popular activities. Campers were permitted to canoe to the Virginia shoreline—a round-trip of over 12 miles—notwithstanding heavy boat traffic on the Potomac River.

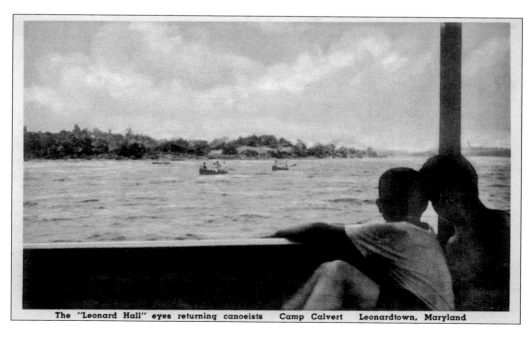

The "Leonard Hall" eyes returning canoeists Camp Calvert Leonardtown, Maryland

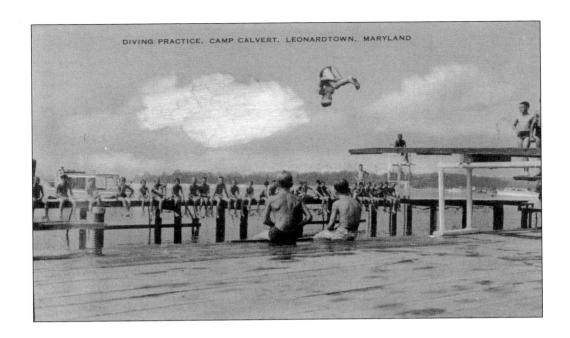

DIVING PRACTICE, CAMP CALVERT, LEONARDTOWN, MARYLAND

COOLING WATER SPORTS. To escape the heat and humidity of the Southern Maryland summer, campers spent many hours swimming in Camp Calvert's Olympic-sized pool, which featured both high and low diving boards. The camp wharf was also used as a swimming venue, though jellyfish and blue crabs made swimming there a bit more challenging.

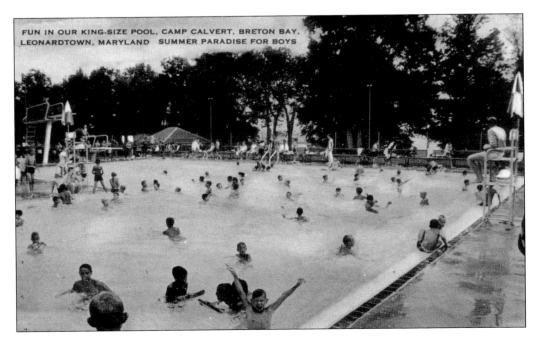

FUN IN OUR KING-SIZE POOL, CAMP CALVERT, BRETON BAY, LEONARDTOWN, MARYLAND SUMMER PARADISE FOR BOYS

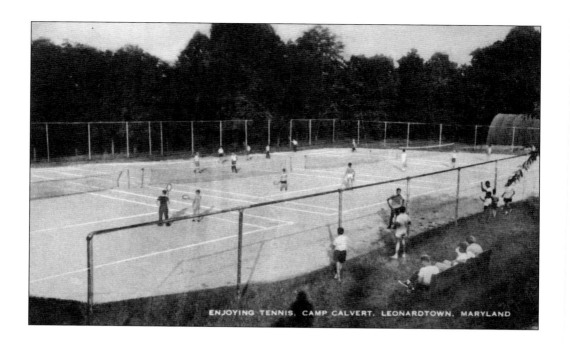

ENJOYING TENNIS, CAMP CALVERT, LEONARDTOWN, MARYLAND

ABUNDANT RECREATION OPTIONS. Camp Calvert offered a full schedule of activities to keep its 150 campers occupied. Boys enjoyed swimming, canoeing, fishing, tennis, archery, baseball, football, and occasional socials with girls from Camp Maria.

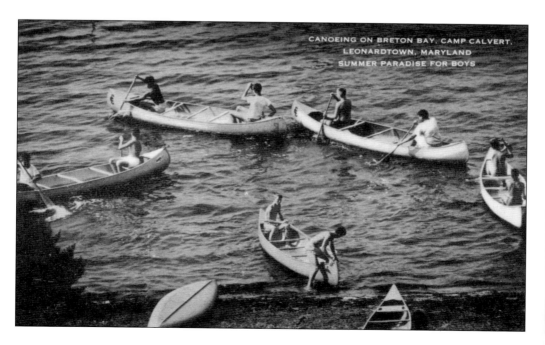

CANOEING ON BRETON BAY, CAMP CALVERT, LEONARDTOWN, MARYLAND
SUMMER PARADISE FOR BOYS

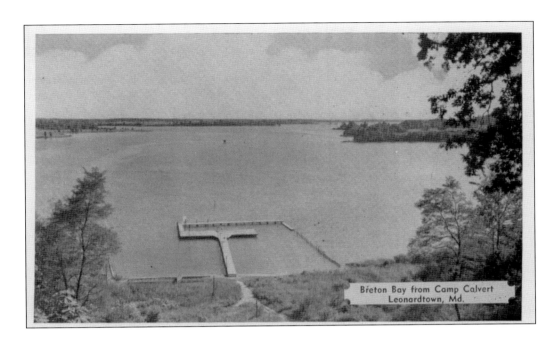

Breton Bay from Camp Calvert
Leonardtown, Md.

PIER AND LOOKOUT. The Camp Calvert Lookout offered a panoramic view of the pier and Breton Bay. It also provided an ideal spying place for the camp's most popular activity, Smuggler's Week. This weeklong, around-the-clock competition pitted campers designated as bootleggers against revenuers. While the specific rules of the game have long been forgotten, roughhousing and mischief were always involved. The Xaverian Brothers believed this competition would toughen up the boys.

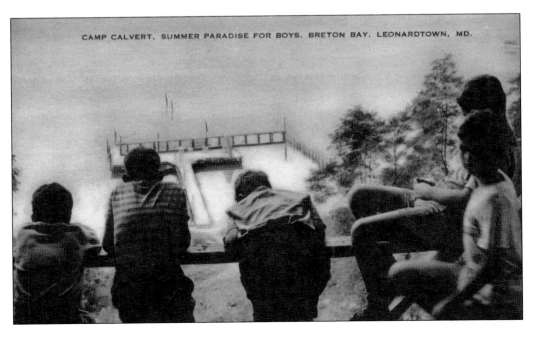

CAMP CALVERT, SUMMER PARADISE FOR BOYS, BRETON BAY, LEONARDTOWN, MD.

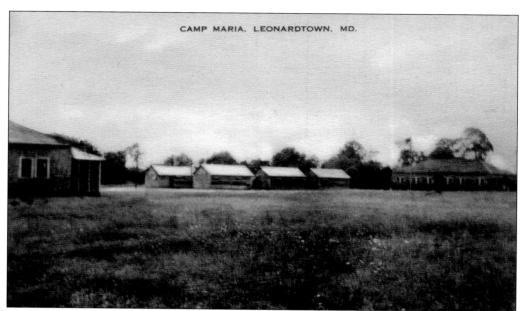

CAMP MARIA. In the mid-1930s, Sr. Mary Aline Kearns, a Sister of Charity of Nazareth and the superior at St. Mary's Academy, dreamed of a place where the academy's girls could enjoy time off during the summer months. In 1937, Camp Maria was established on the eastern shore of Breton Bay, near Abell's Wharf. The camp's facilities were rustic but comfortable, primarily composed of one-story frame cabins with shuttered windows. The camp operated until 1969 when it was converted into a retreat center.

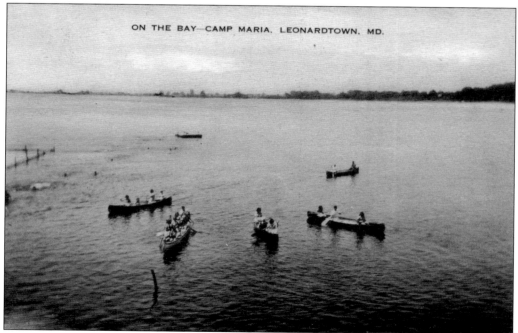

CANOEING ON BRETON BAY. Camp Maria's location on the shores of Breton Bay allowed easy access to the water. Canoeing on the bay was among the campers' favorite activities.

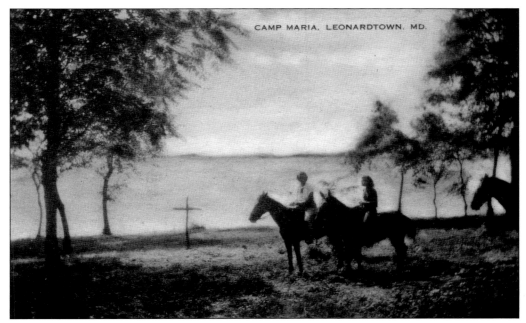

ABUNDANT ACTIVITIES. Camp Maria was promoted as a place "for girls to enjoy outdoor activities and appreciate the beauty of nature." Campers enjoyed archery, horseback riding, swimming, diving, canoeing, boating, crafts, closely chaperoned socials with boys from Camp Calvert, and, of course, chapel services.

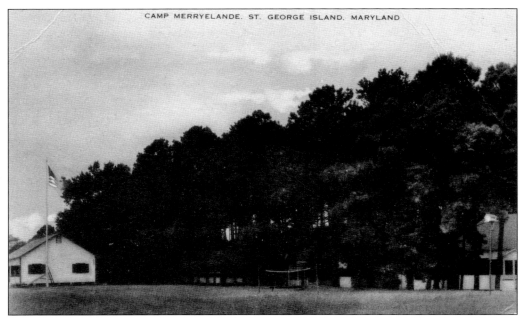

CAMP MERRYELANDE. Founded by the Sisters of the Holy Cross, Camp Merryelande was a summer camp for girls located on St. George Island from 1938 to 1963. The camp is currently operated as a commercial resort, featuring 13 cottages and additional beach campsites.

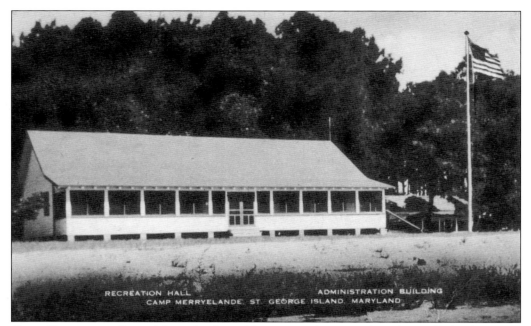

CAMP FACILITIES. Camp Merryelande could accommodate 55 girls with a staff of eight sisters, four lay counselors, a cook, a janitor, and a handyman. The camp consisted of a chapel, dining room, kitchen, recreation hall, shower building, and four sleeping cabins

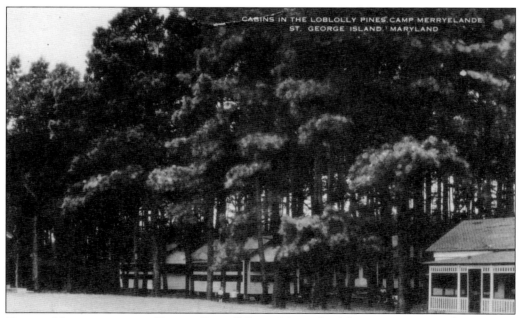

CABINS NESTLED IN THE PINES. One of Camp Merryelande's most prominent features was groves of 100–foot-tall loblolly pines. These trees replaced ancient hardwoods that British sailors chopped down during the War of 1812. The British also reportedly burned every house, fence, and pasture on St. George Island.

Seven

LEONARDTOWN

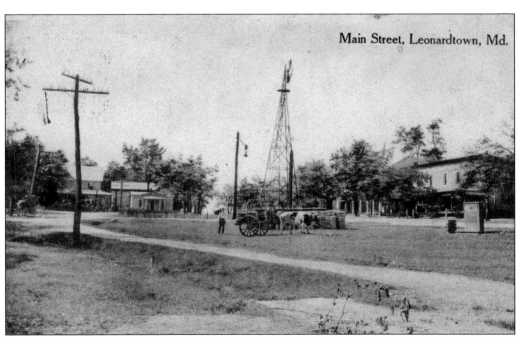

LEONARDTOWN, THE COUNTY SEAT. Leonardtown has served as the commercial and government center of St. Mary's County for over 300 years. Originally named Seymour Town in the early 1700s in honor of royal governor John Seymour, it was later renamed Leonard Town after proprietary governor Benedict Leonard Calvert.

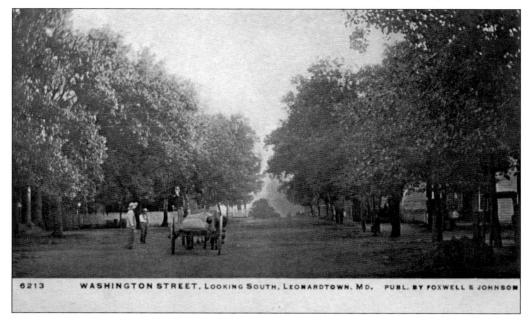

6213 WASHINGTON STREET, Looking South, Leonardtown, Md. Publ. by Foxwell & Johnson

WASHINGTON STREET, VIEW LOOKING SOUTH. Leonardtown's main road, Washington Street, runs from the Leonardtown Wharf on Breton Bay north to an intersection with State Route 5. Pictured here in the early 1900s, trees and private homes appear where the town square and commercial center will be built in later years.

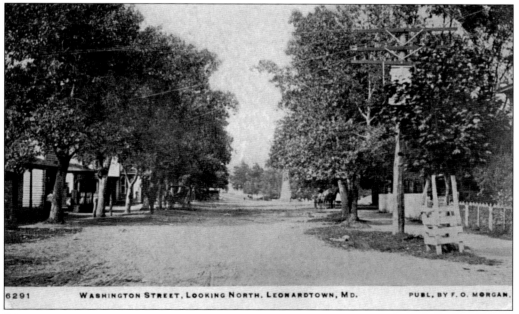

6291 WASHINGTON STREET, Looking North, Leonardtown, Md. Publ. by F. O. Morgan.

WASHINGTON STREET, VIEW LOOKING NORTH. This image shows a view of Washington Street looking north from near the courthouse. A telegraph pole and wires appear on the right. Electrical lines would not reach Leonardtown until the 1930s.

EAST SIDE OF THE SQUARE. Barely recognizable, this is the Leonardtown town square as it appeared in the early 1900s. The Hotel St. Mary's is partially obscured by trees in the middle of the photograph. (Courtesy of St. Mary's County Historical Society.)

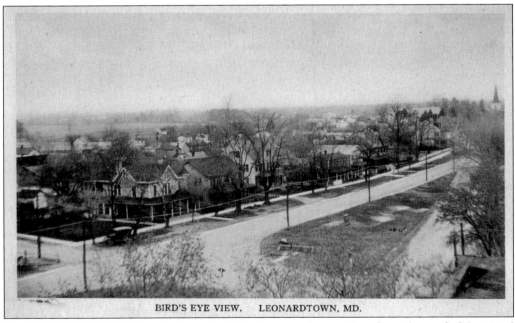

BIRD'S EYE VIEW. LEONARDTOWN, MD.

BIRD'S-EYE VIEW OF LEONARDTOWN. This photograph was taken from the roof of the Hotel St. Mary's in the late 1920s. The intersection of Washington and Fenwick Streets is in the foreground, and the steeple of old St. Aloysius Church is visible in the upper right corner. The houses located on the west side of Washington Street have been replaced by stores and office buildings. (Courtesy of St. Mary's County Historical Society.)

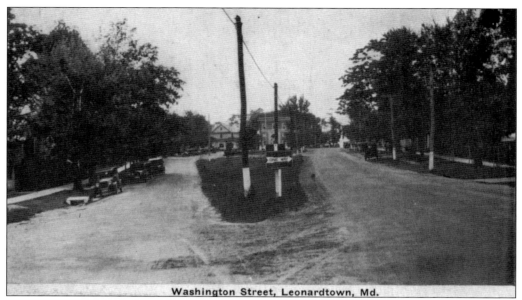

Washington Street, Leonardtown, Md.

INTERSECTION OF FENWICK AND WASHINGTON STREETS. One of today's busiest intersections in Leonardtown is much more subdued in this photograph taken in the 1920s. Across the town square, the First National Bank of St. Mary's is visible in the distance.

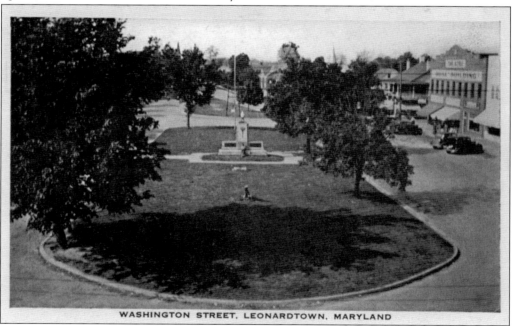

WASHINGTON STREET, LEONARDTOWN, MARYLAND

THE SQUARE. The Leonardtown town square divides Washington Street at the intersection of Park Avenue. The Duke Building, built by Roland B. Duke in the 1920s, is on the right. With a prime location on the square, the Duke Building has housed an automobile sales showroom, grocery store, social hall, bowling alley, theater, soda fountain, and bar. Today, the building is home to Café des Artistes, an upscale bistro featuring country French cuisine by Chef Loïc Jaffres. (Courtesy of St. Mary's County Historical Society.)

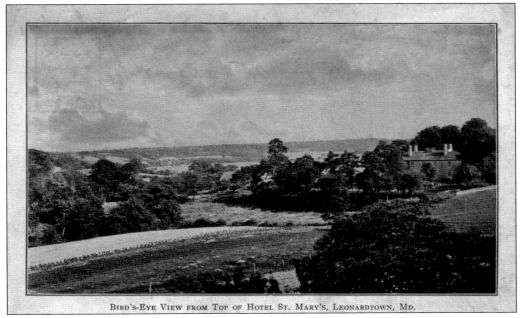

BIRD'S-EYE VIEW FROM TOP OF HOTEL ST. MARY'S, LEONARDTOWN, MD.

VIEW FROM HOTEL ST. MARY'S. For many years, the Hotel St. Mary's was the tallest building in Leonardtown. The view from the hotel was spectacular. Tudor Hall is visible on the right, and a panoramic vista of Breton Bay appears on the horizon.

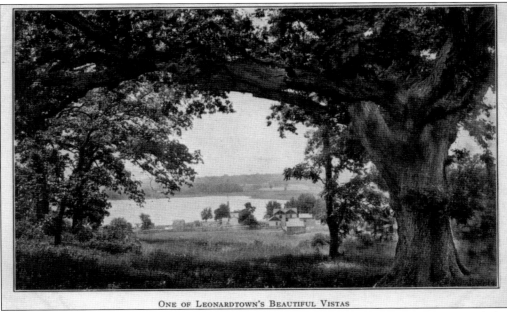

ONE OF LEONARDTOWN'S BEAUTIFUL VISTAS

VIEW OF BRETON BAY FROM TOWN HILL. Leonardtown sits on a gently sloping hill that affords sweeping views of the countryside. This photograph was taken near Tudor Hall and shows Breton Bay near the Leonardtown Wharf.

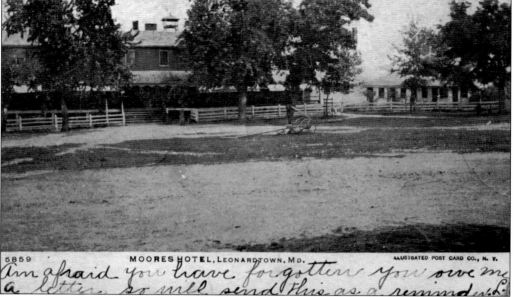

MOORES HOTEL, LEONARDTOWN, MD.

Am afraid you have forgotten you owe me a letter, so will send this as a reminder.

MOORE'S HOTEL. Moore's Hotel was one of the first lodging facilities build in Leonardtown. Its proprietor, James W. Jackson Moore, was a Confederate sympathizer who helped smuggle St. Mary's County men across the Potomac River to Virginia to serve in the Confederate army. The hotel also served as St. Mary's County's first unofficial fire station. Buckets, two ladders, and hooks were stored under the hotel's front steps ready for use if a fire broke out in town.

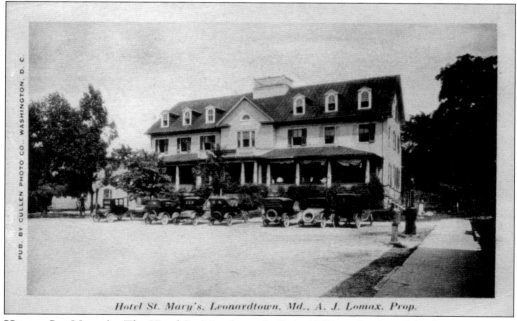

Hotel St. Mary's, Leonardtown, Md., A. J. Lomax, Prop.

HOTEL ST. MARY'S. The Hotel St. Mary's was built in 1907 on the site of the former Moore's Hotel. Its grand opening occurred during a gala homecoming week in October 1907, which welcomed the scattered sons and daughters of Old St. Mary's back to the "Mother County." An extensive program included a formal ball, oyster scald, musicale, horse races, and card parties.

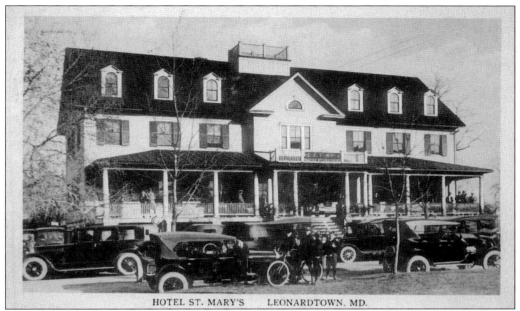

HOTEL ST. MARY'S LEONARDTOWN, MD.

A Busy Day at the Hotel. The hotel was not only a respectable resort for visitors from Washington, DC, and Baltimore but also the social hub for Leonardtown society. It featured large guest rooms, spacious porches, indoor bath facilities, steam heat, artesian well water, and an immense lobby used for evening dances.

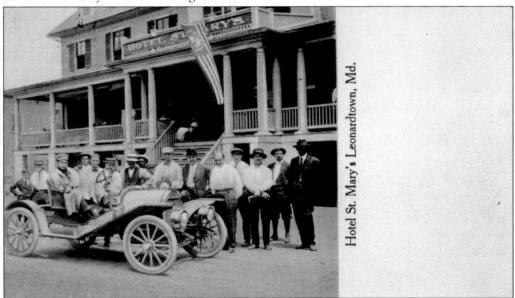

Hotel St. Mary's Leonardtown, Md.

Automobiles Come to Leonardtown. In the early 1910s, a group of gentlemen examines a new car while ladies watch from the safety of the hotel's porch. The driver wears a driving coat and goggles, appropriate motoring clothes in those days. The five men on the right-hand side are, from left to right, Roland B. Duke, Robert Mattingly, Col. R.B. Duke, Walter Raley, and Thomas Sanderson. The flag above the staircase is the US yacht ensign, typically used by recreational vessels sailing in national waters. (Courtesy of St. Mary's County Historical Society.)

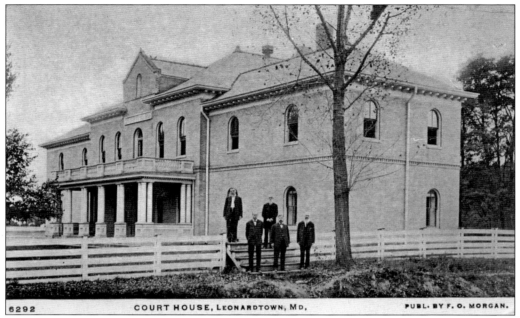

6292 COURT HOUSE, LEONARDTOWN, MD, PUBL· BY F. O. MORGAN.

1901 COURTHOUSE. St. Mary's County's first courthouse, a frame structure, was constructed in Leonardtown in 1710. In the 1730s, it was replaced by a brick building, which burned down in 1831, destroying many irreplaceable land and census records. A new courthouse was constructed in 1901. (Courtesy of George A. Kirby III.)

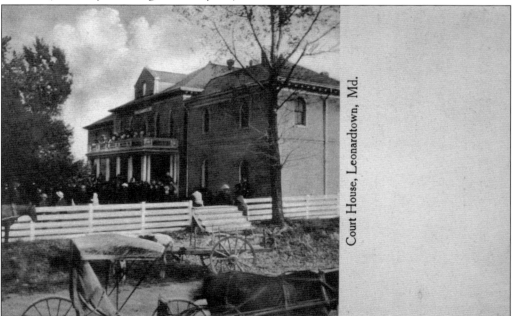

Court House, Leonardtown, Md.

AUCTION ON THE COURTHOUSE STEPS. The courthouse grounds were used for a variety of activities, including civic gatherings, property auctions, and executions. According to tradition, a hanging tree was located in the yard, though historical evidence indicates scaffolds typically were constructed for executions.

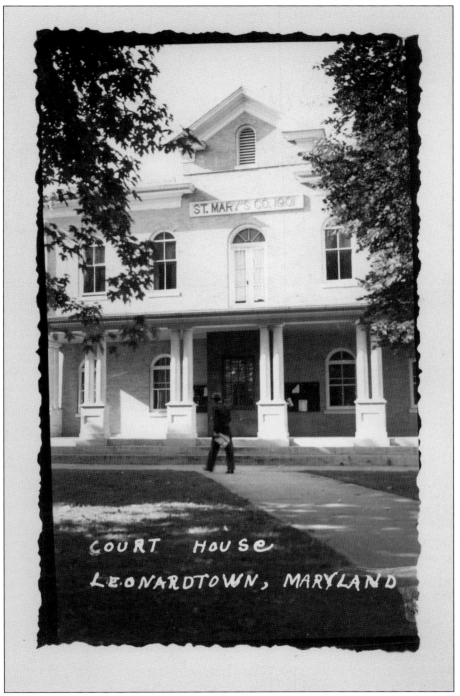

COURTHOUSE ENTRANCE. The 1901 courthouse was constructed in a Victorian style by the B.I. Smith Company at a cost of $22,000. At the cornerstone ceremony, a speech was offered by Joseph H. Key, a prominent Leonardtown lawyer, and the stone was laid by George B. Dent, a justice of the peace.

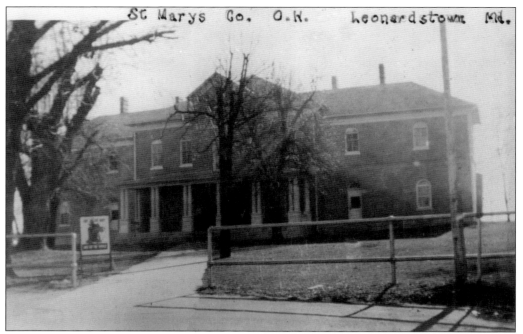

COURTHOUSE AFTER WORLD WAR I. The 1901 courthouse, while modest in both size and appearance, served St. Mary's County well through World Wars I and II. Pictured here around the time of World War I, the courthouse had changed little from the day it opened.

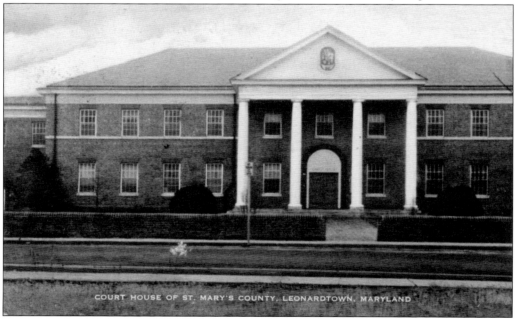

NEW COURTHOUSE. As the population of St. Mary's County grew, the 1901 courthouse could no longer meet the area's needs. It was extensively renovated in 1957. The yellow brick facing on the old courthouse was replaced with red brick and a pediment facade. Another extensive renovation and addition was completed in 2001. (Courtesy of George A. Kirby III.)

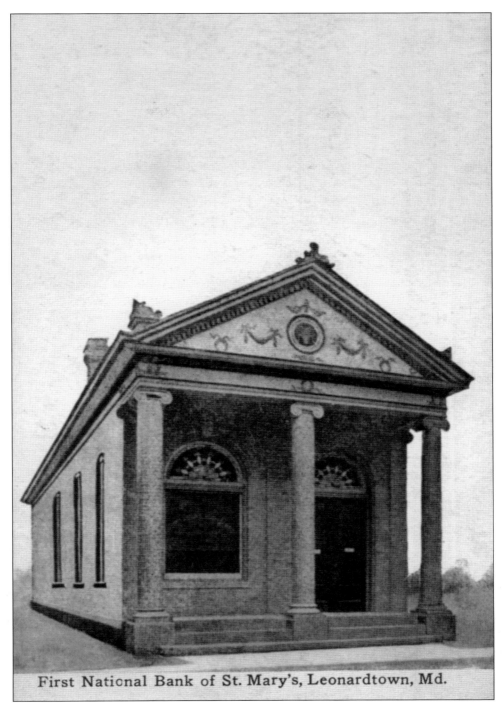

First National Bank of St. Mary's, Leonardtown, Md.

FIRST NATIONAL BANK OF ST. MARY'S. Incorporated in 1901, the First National Bank of St. Mary's constructed the first dedicated bank building in St. Mary's County in 1903. The bank quickly outgrew the modest, one-story brick building pictured here and planning for the construction of a larger structure began in 1917.

THE LEONARDTOWN BANK. Built between 1912 and 1913, the Leonardtown Bank of the Eastern Shore Trust Company was located on the west side of Washington Street near the courthouse. The one-story brick building was constructed in the Classical Revival style and located between the home of Judge B. Harris Camalier and a lot known as the Storehouse, which included a log structure. The building operated as a bank until 1951 when it was purchased by J. Ernest and T. Webster Bell and converted to office space. (Courtesy of St. Mary's County Historical Society.)

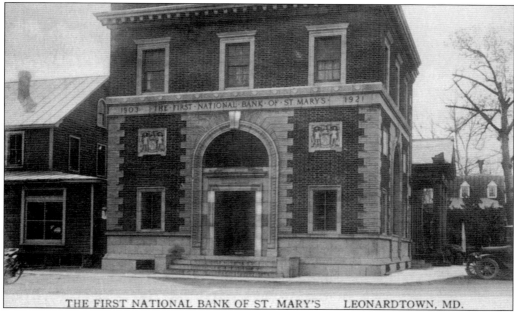

NEW FIRST NATIONAL BANK. Located at the southwest corner of Park Avenue and Washington Street, the new First National Bank of St. Mary's was constructed in 1921. The large Classical Revival building immediately dominated the town square, blocking the view of the courthouse and offering a tangible display of Leonardtown's economic prosperity.

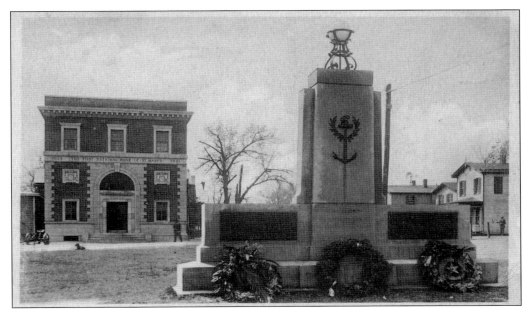

SOLDIERS AND SAILORS MONUMENT. Also known as the World War I memorial, the Soldiers and Sailors Monument was dedicated on November 11, 1921, in honor of 27 men from St. Mary's County who lost their lives during World War I. The monument is located on the Leonardtown town square and is the focal point for the town's annual Veterans Day parade. (Courtesy of St. Mary's County Historical Society.)

VIEW OF THE FIRST NATIONAL BANK AND TOWN SQUARE. As St. Mary's County grew, so did its primary bank. The First National Bank of St. Mary's was significantly enlarged in 1966. The building later became the headquarters for the Mercantile Southern Maryland Bank and then a branch of PNC Bank. In July 2013, PNC closed the branch.

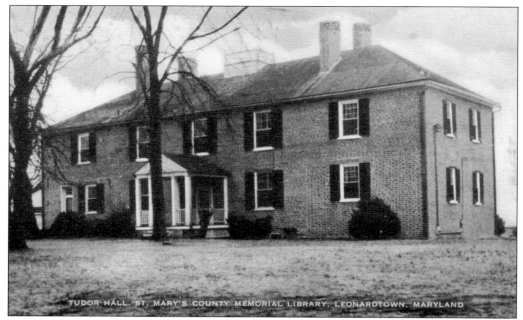

TUDOR HALL. Built in 1744 and enlarged in the 1760s, Tudor Hall was the home of the uncle of Francis Scott Key, who penned "The Star-Spangled Banner." Mary Patterson Davidson, the last private owner of Tudor Hall, donated the building to St. Mary's County for use as library. Today, Tudor Hall houses the research library and archives for the St. Mary's County Historical Society.

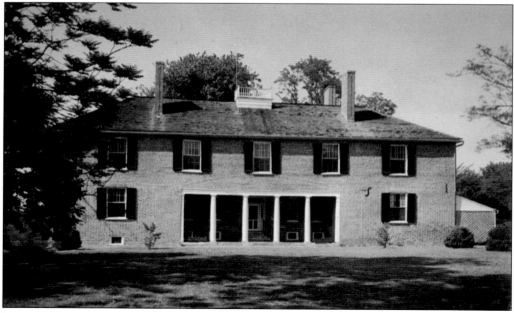

TUDOR HALL PORTICO. Tudor Hall contains a number of unusual features, including an inset portico that faces Breton Bay. According to legend, the ghost of a member of the Key family likes to serenely rock in a rocking chair on this portico.

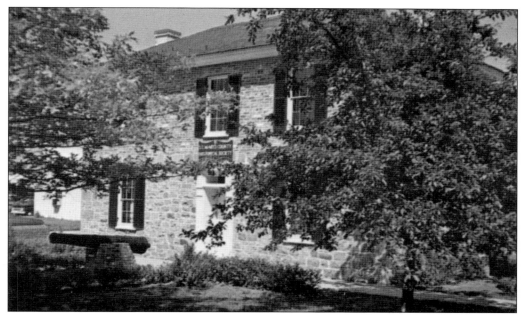

THE OLD JAIL. Built in 1858 next to the courthouse, the old jail housed prisoners until 1942. The two-story granite and brick building contained quarters for the jail keeper's family on the first floor and cells on the second floor, where prisoners were segregated by gender and race. Today, the building serves as a museum operated by the St. Mary's County Historical Society.

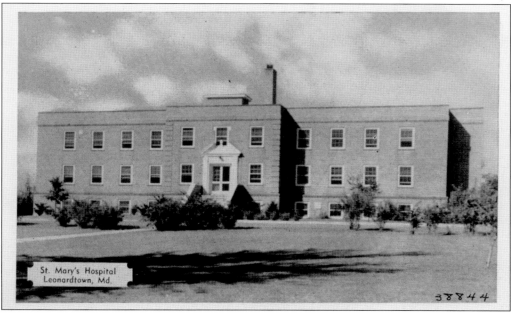

St. Mary's Hospital
Leonardtown, Md.

ST. MARY'S HOSPITAL. Leonardtown's first hospital was a modest frame house on Fenwick Street rented from Margaret and Francis Greenwell in 1912 for $10 a month. A group of prominent citizens formed a fundraising committee, and a permanent hospital was constructed on State Route 5 in 1915. This building was repeatedly renovated and added on to in response to changing community needs. In 1984, a new hospital was constructed half a mile north on Route 5.

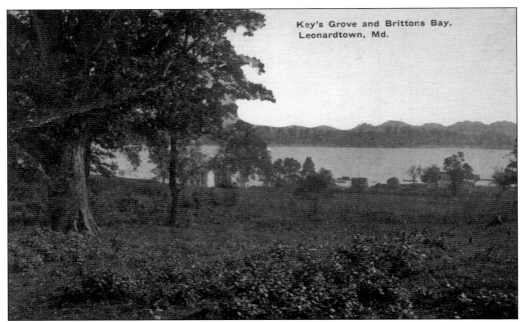

Key's Grove and Brittons Bay, Leonardtown, Md.

BRETON BAY FROM KEY'S GROVE. Leonardtown prospered because of its proximity to the water. Located on placid Breton Bay, the town was easily reachable by boat and had a safe harbor. This accessibility proved detrimental during the War of 1812. On July 19, 1814, the British landed at Leonardtown Wharf and proceeded to burn townspeople's household items and military supplies.

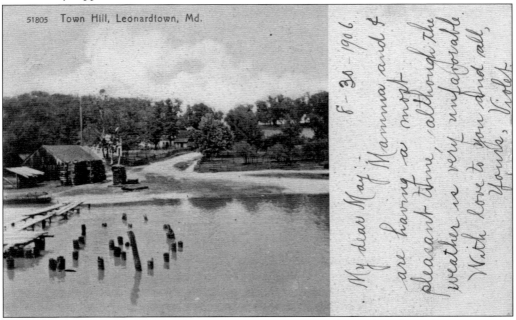

51805 Town Hill, Leonardtown, Md.

6-30-1906.

My dear May:
Mamma and I are having a most pleasant time, although the weather is very unfavorable. With love to you and all,
Yours, Violet.

TOWN HILL. Leonardtown sits on Town Hill, a gentle slope descending from the town square to the wharf at Breton Bay. Although the slope was an obstacle for farmers delivering goods to the wharf by oxcart, it was an ideal place for winter sledding.

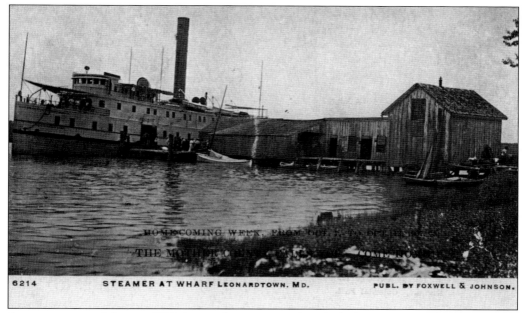

LEONARDTOWN WHARF. This image shows a steamship docked at the Leonardtown wharf in 1907. Steamships arrived several times each week, loading and unloading passengers, mail, and freight for Baltimore, Washington, or points in between. Local farmers and entrepreneurial boys met the ships to sell fresh produce, meat, and seafood for passengers' meals. Dinners on board were legendary—feasts included crabs, oysters, fried chicken, diamondback terrapin, canvasback duck, quail, rockfish, flounder, turkey, and beefsteak. (Courtesy of St. Mary's County Historical Society.)

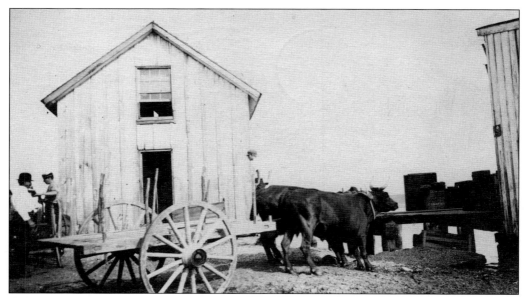

OXEN DELIVER GOODS TO LEONARDTOWN WHARF. In the days before flatbed trucks, farmers used teams of oxen to haul goods for shipping to Washington, DC, and Baltimore. Pictured here in the early 1900s, a yoke of oxen waits for a delivery to be unloaded from a steamboat.

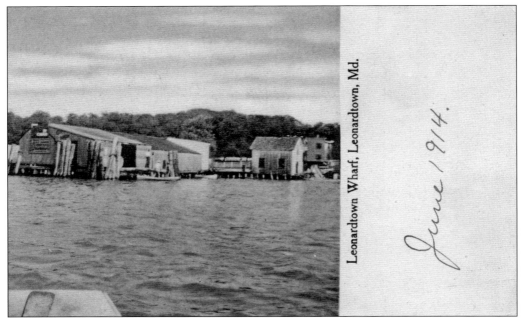

June / 914.

Leonardtown Wharf, Leonardtown, Md.

WAREHOUSES AT THE WHARF. The Leonardtown Wharf was a hub for St. Mary's County's commercial activity in the early part of the 20th century. Warehouses surrounded the wharf, and F.W. Cisel operated an ice plant adjacent to the Leonardtown water pumping station. Later known as the St. Mary's Ice & Fuel Company, the ice plant burned down and was later demolished.

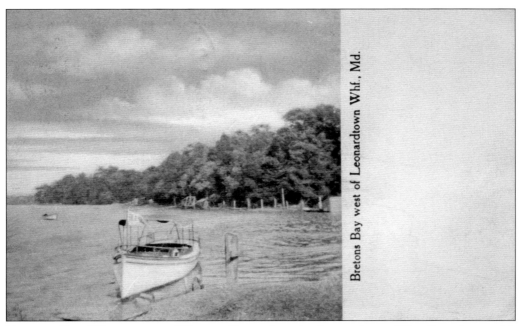

Bretons Bay west of Leonardtown Whf., Md.

BRETON BAY WEST OF THE WHARF. Even when the Leonardtown Wharf was busy with commercial activity, the rest of Breton Bay was placid. Pictured here in the 1910s, a small runabout boat is moored in Breton Bay.

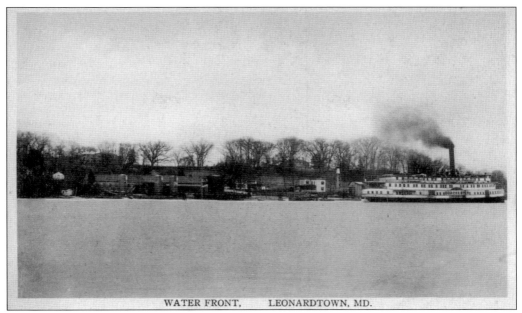

THE LEONARDTOWN WATERFRONT. Until the 1930s, steamships were the primary means of transportation and shipping to Washington and Baltimore. Pictured here in the 1920s, the steamer *Dorchester* is docked at Leonardtown Wharf. Between 1920 and 1932, the *Dorchester* made the Potomac run among Washington, Alexandria, Mount Vernon, Leonardtown, St. Mary's City, and other points along the Potomac River and its tributaries. (Courtesy of St. Mary's County Historical Society.)

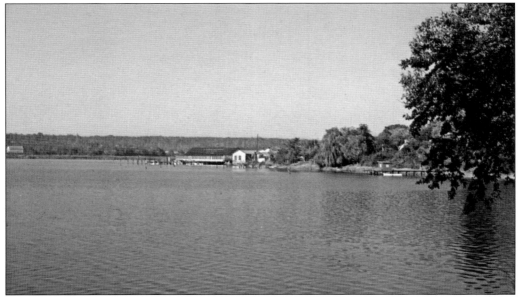

DEMISE OF THE WHARF. In contrast to its bustling days in the first half of the 20th century, the Leonardtown Wharf was reduced to a few small storage buildings by the 1960s. After years of neglect, the wharf has been converted into a lovely waterfront park, and there are plans for an extensive redevelopment project.

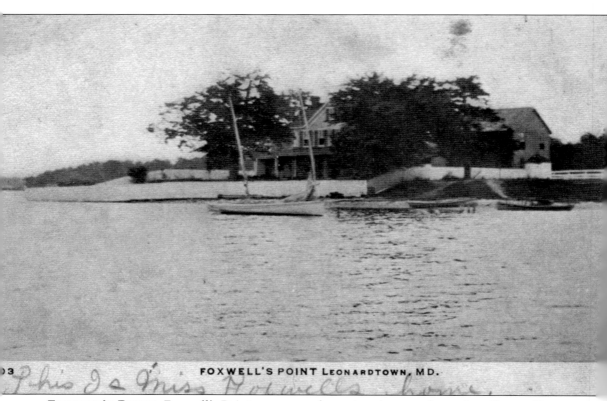

FOXWELL'S POINT LEONARDTOWN, MD.

FOXWELL'S POINT. Foxwell's Point was a popular swimming area located on Breton Bay. Undeterred by jellyfish and sharp oyster shells, children swam, took turns using a diving board, and explored a sunken boat wreck.

Eight

NAS Patuxent River and Lexington Park

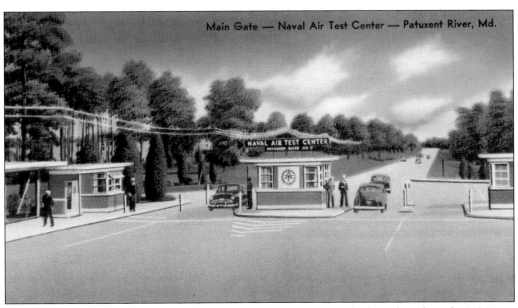

NAVAL AIR STATION PATUXENT RIVER. After the Japanese bombed Pearl Harbor, the US Navy wanted to consolidate its widely dispersed air-testing facilities. The Cedar Point peninsula—located near Washington, DC, but isolated enough to permit exhaustive aircraft testing—was selected as the site of the new testing facility. Construction began in 1942, and NAS Patuxent River was commissioned less than a year later on April 1, 1943. In 1945, the Naval Air Test Center was formed as a separate testing operation at the base.

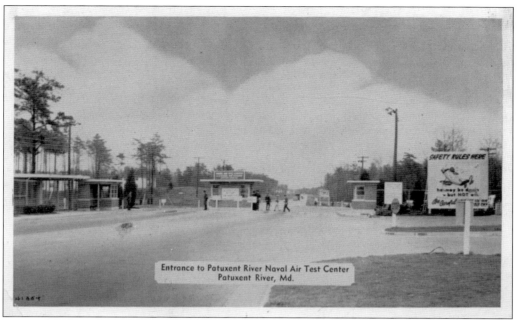

MAIN GATE. When NAS Patuxent River was commissioned in 1943, the base's main gate was situated at the intersection of Cedar Point Road, Three Notch Road, and Great Mills Road. As the base grew due to defense restructuring in the 1990s, a new main gate was opened about a mile north of the original.

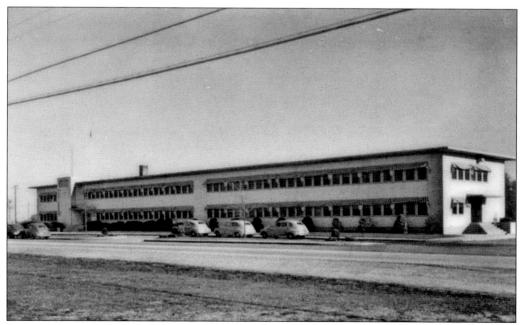

ADMINISTRATION BUILDING. Constructed in 1943, the administration building was the original headquarters for NAS Patuxent River, located at the center of the base on Cedar Point Road. The building continues to serve as administrative offices for the naval air station.

SHIP'S SERVICE BUILDING. Better known as the Navy Exchange, the Ship's Service Building contained a retail store, bowling alley, cafeteria, barbershop, tailor, dry cleaner, and florist. It was located on Cedar Point Road and provided one-stop shopping for the base's military personnel. A new Navy Exchange is located on Cuddihy Road.

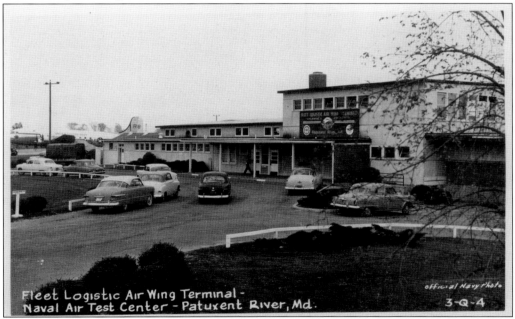

FLEET LOGISTIC AIR WING TERMINAL. The Fleet Logistic Air Wing Terminal housed the VR-1 squadron, an air transport group moved from Norfolk, Virginia, to NAS Patuxent River in 1943. VR-1 currently resides at Andrews Air Force Base and provides dedicated airlift services for the secretary of the Navy, chief of naval operations, and commandant of the Marine Corps.

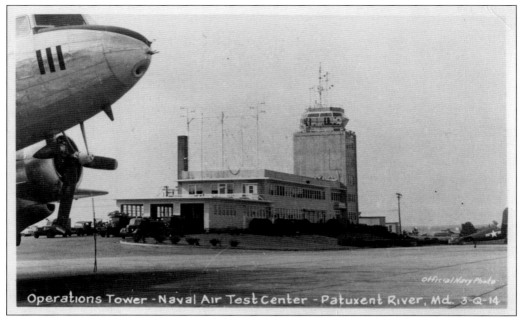

Operations Tower - Naval Air Test Center - Patuxent River, Md. 3-Q-14

OPERATIONS TOWER. The operations tower provided air traffic controllers with a bird's-eye view of the base's airfield. Today, the new Air Operations Tower is the tallest building in Southern Maryland.

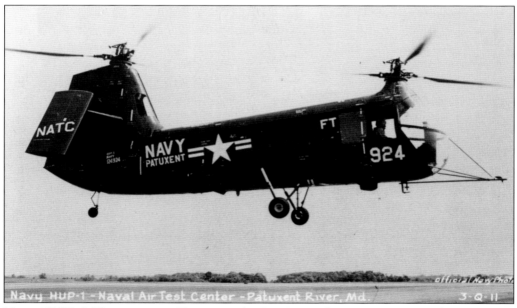

Navy HUP-1 - Naval Air Test Center - Patuxent River, Md. 3-Q-11

NAVY HUP-1 HELICOPTER. Known as the Retriever, the HUP-1 was a utility transport search-and-rescue helicopter operating from aircraft carriers and other ships beginning in 1949. During the model's 20-year service life, these helicopters saved the lives of countless sailors and marines downed at sea. Astronaut John Glenn was ferried by a HUP-1 to a recovery ship after his historic spaceflight orbiting the Earth.

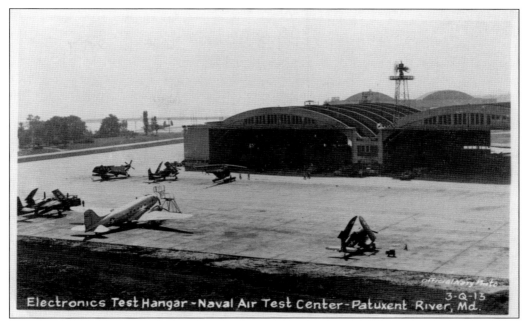

Electronics Test Hangar - Naval Air Test Center - Patuxent River, Md.
3-Q-13

ELECTRONICS TEST HANGAR. In the early 1950s, the Electronics Test Hangar was used for testing radar, electronic countermeasures, and direction-finding equipment for aircraft. The large aircraft located on the left side of the image above is an R4D "Gooney Bird," often used as a flying test bed for electronics equipment.

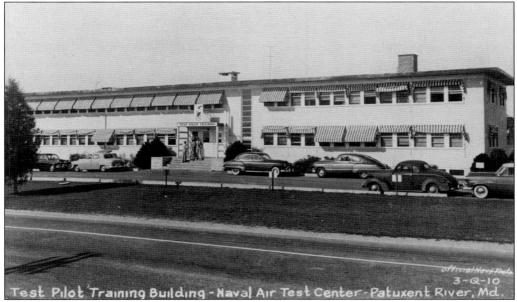

Test Pilot Training Building - Naval Air Test Center - Patuxent River, Md.
3-Q-10

TEST PILOT SCHOOL. The US Naval Test Pilot School was established in 1945 to train Navy, Marine Corps, Army, and Army Air Forces test pilots, flight test engineers, and flight test officers. The school's selection process remains among the most competitive in military service. Alumni include astronauts Scott Carpenter, Pete Conrad, John Glenn, Jim Lovell, Wallie Schirra, and Alan Shepard.

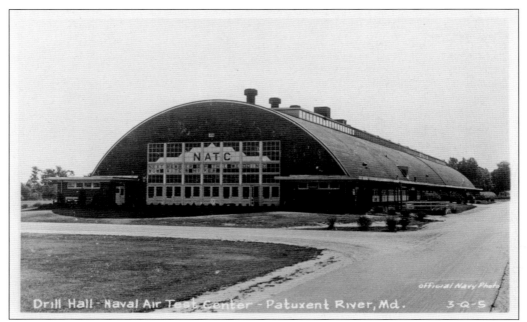

DRILL HALL. Originally constructed as an indoor drill deck, the NAS Patuxent River Drill Hall evolved into a center for indoor recreation. Today, the drill hall contains an indoor pool, bowling alley, weight rooms, strength and cardiovascular equipment, and basketball, racquetball, and volleyball courts.

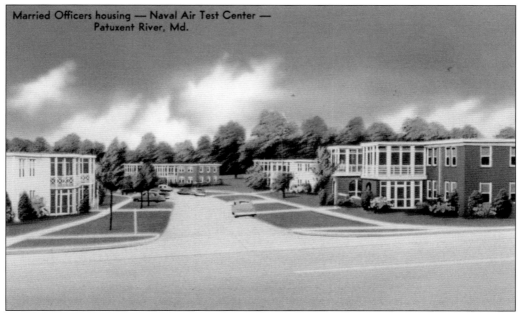

MARRIED OFFICERS' HOUSING. Housing for married officers was located in two-story buildings built on either side of Cuddihy Road. The complex has been demolished and replaced by more modern housing options.

COMMISSIONED OFFICERS' MESS. Known as the Officers Club or colloquially as the O Club, the commissioned officers' mess was located on the banks of the Chesapeake Bay near Cedar Point. To accommodate the base's increasing population, a new Officers Club and conference center, known as River's Edge, was opened in February 2010.

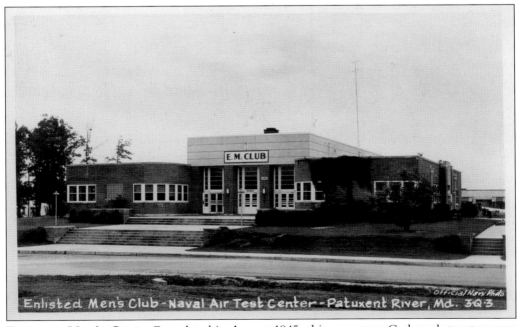

ENLISTED MEN'S CLUB. Completed in August 1945, this one-story C-shaped structure was used as NAS Patuxent River's USO building until it became the Enlisted Men's Club in 1951. In July 1978, the building was repurposed as the base museum but was subsequently demolished.

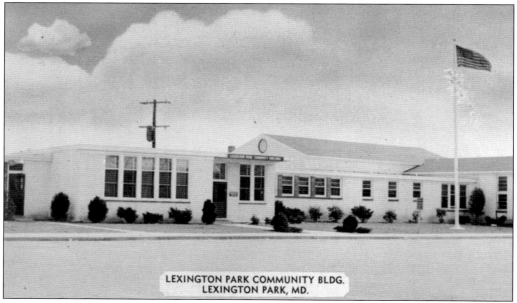

LEXINGTON PARK COMMUNITY BLDG.
LEXINGTON PARK, MD.

LEXINGTON PARK. In 1943, the influx of civil and military personnel at the new Navy base caused a severe housing shortage in St. Mary's County. In response, the Navy hastily constructed housing and amenities just outside the base's front gate in an area known as Jarboesville, which the Navy renamed Lexington Park in honor of the USS *Lexington*, an aircraft carrier lost in the Battle of the Coral Sea.

PO, Lexington Park, Md.

LEXINGTON PARK POST OFFICE. The first post office in Lexington Park is shown here in the late 1940s. The building would later be converted to a community center and library.

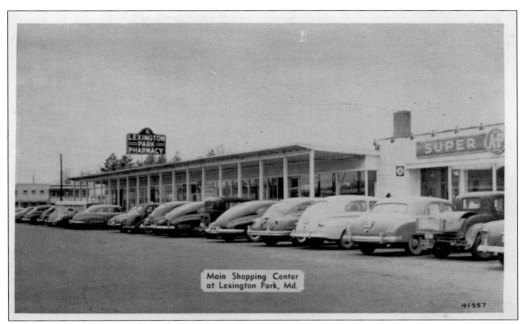

Main Shopping Center
at Lexington Park, Md.

MAIN SHOPPING CENTER. When NAS Patuxent River opened in 1943, the formerly sleepy intersection of Great Mills Road and Three Notch Road exploded with new commercial activity. A stone's throw from the base's front gate, a strip of stores located on Tulagi Place was anchored on one end by a clothing store named the Hub and on the other end by an A&P supermarket. Other stores included Dietz Shoes, the Lexington Park Pharmacy, and the Park Men's Shop.

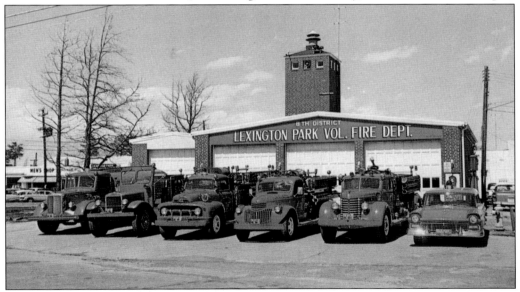

LEXINGTON PARK VOLUNTEER FIRE DEPARTMENT. In October 1943, the Lexington Park Volunteer Fire Department was incorporated. While the department waited for its first fire engine to arrive, it used a hose cart pulled by two horses. This proved unsatisfactory, so the Navy loaned the department a jeep and a pump loaded on a trailer. The fire station pictured here was constructed in 1945.

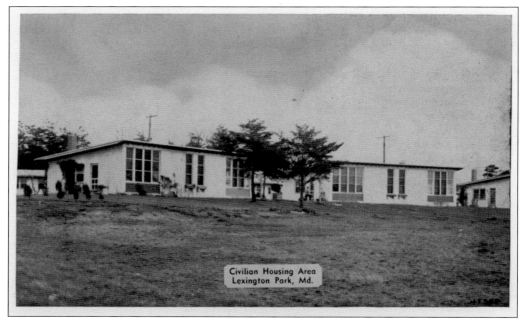

THE FLATTOPS. Lexington Manor, known informally as "the Flattops," was a close-knit community of 350 duplex homes located just south of the NAS Patuxent River main gate in Lexington Park. The homes were constructed by the federal government in 1943–1944 to provide much-needed housing for the surge of civilian employees who arrived to work at the new Navy base. All but two homes were razed in 2005 after decades of deterioration made the neighborhood a symbol of blight.

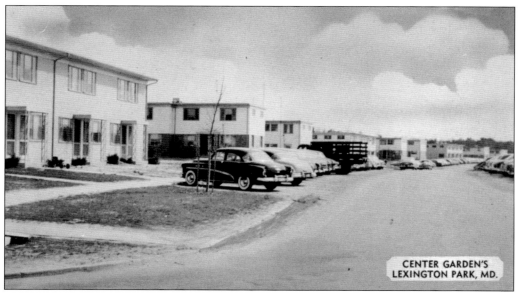

CENTER GARDENS. Center Gardens was a 1,000-unit apartment complex constructed by the federal government in Lexington Park in the early 1950s. It housed a mixture of civilian and enlisted military families and had a separate section for officers known as Officers Court.

Nine

At Work and Play

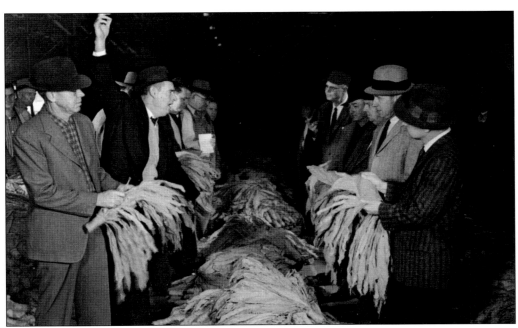

Tobacco Auction. For more than three centuries, tobacco was the primary cash crop in St. Mary's County. Green tobacco stalks and leaves were harvested in late summer and cured to golden brown by winter's end. Through the 19th century, farmers shipped hogsheads of tobacco by steamer for sale in Baltimore and other ports. In 1939, local tobacco auctioning began. In response to health concerns, the State of Maryland announced a voluntary tobacco buyout program in 1999, which paid farmers to stop growing the crop. Sales of Maryland tobacco quickly declined, and the last tobacco auction in Southern Maryland was held in March 2006. (Courtesy of St. Mary's County Historical Society.)

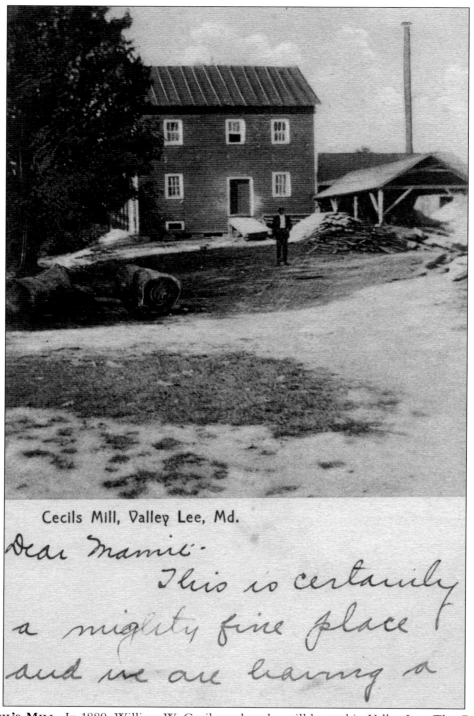

Cecils Mill, Valley Lee, Md.

Dear Mamie..
This is certainly
a mighty fine place
and we are having a

CECIL'S MILL. In 1889, William W. Cecil purchased a mill located in Valley Lee. The Cecil family operated the mill for over 60 years until it burned to the ground in 1954. The mill's steam engine sits in front of the Valley Lee Post Office as a monument to the property's former use.

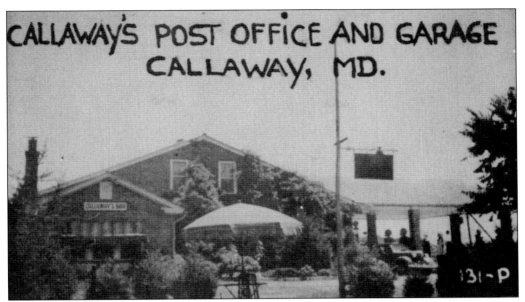

CALLAWAY SERVICE STATION. William Levi Callaway opened a car dealership, garage, and service center in 1923 at the intersection of State Route 5 and Piney Point Road. By 1937, the frame structure had been replaced by the brick building pictured here, the car dealership had closed, and a bar and restaurant had been added. The Callaway family lived above the service station in the two-bedroom upper story.

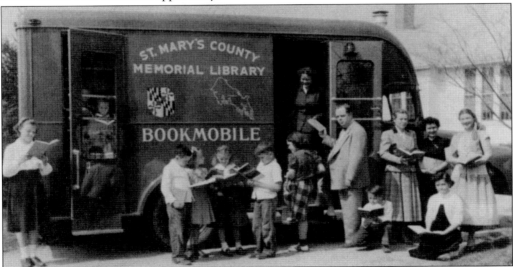

ST. MARY'S COUNTY MEMORIAL LIBRARY BOOKMOBILE. The library traces its roots to the St. Mary's Reading Room and Debating Society, founded in the late 1830s as a forum for discussion of books and topics of the day. When the society disbanded after World War I, it donated its book collection to Leonardtown. In 1948, Mary Patterson Davidson deeded Tudor Hall to the county for use as a library. A few years later, a bookmobile was added to reach residents living outside of Leonardtown. By the early 1950s, the bookmobile visited 33 stops each month, and over half of the 14,000 library books checked out each year came from the bookmobile. (Courtesy of St. Mary's County Historical Society.)

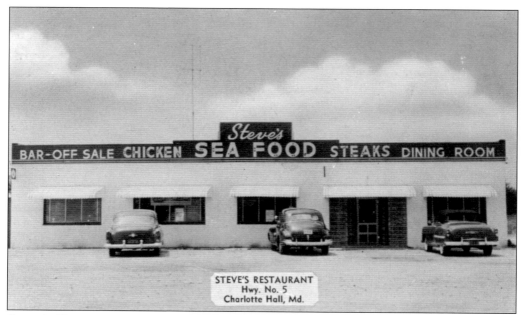

STEVE'S RESTAURANT. Located on the west side of State Route 5 in Charlotte Hall, Steve's Restaurant served a continental menu and drinks during the 1940s and 1950s.

STEVE DULIN'S STEAK HOUSE. Steve Dulin's Steak House was a well-known restaurant in Charlotte Hall that served fine steaks and seafood. Many people stopped at Steve Dulin's for a bite to eat after returning from "up the road." Today, the building is used as a casual restaurant known as St. Mary's Landing.

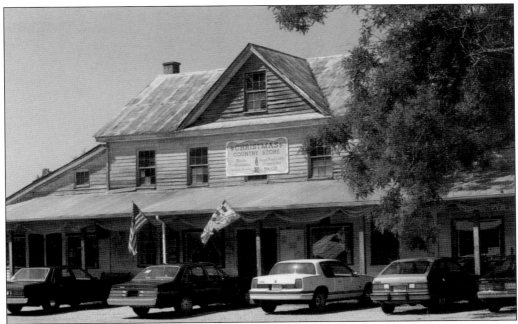

Cecil's Store. In 1906, John T. Cecil constructed a country store directly across Indian Bridge Road from Cecil's Mill. The store served as the Great Mills Post Office from 1907 until around the 1960s. The Cecil family closed the store in 1976, but the building now houses a popular gift shop and home interior store.

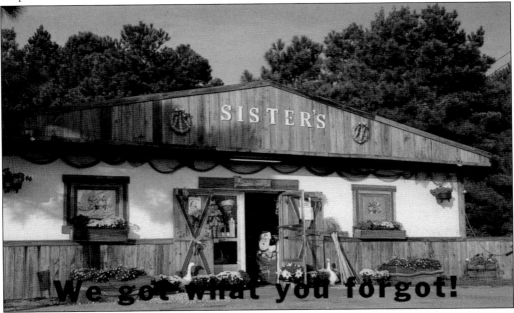

Sister's Place. Located in Scotland, just outside the gates to Point Lookout State Park, Sister's Place was everyone's last stop for sodas, snacks, and suntan lotion before heading to the beach. On the way home from the park, steamed hard crabs could be purchased at the back door of the store.

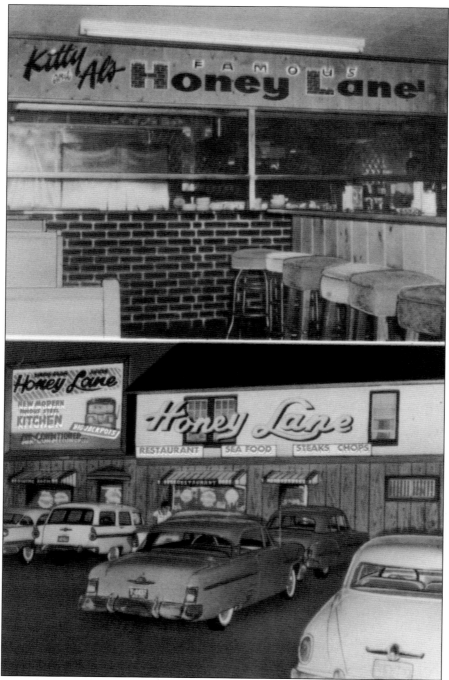

HONEY LANE. After the Naval Air Station Patuxent River opened in 1943, many bars and lounges cropped up near the base's main gate in Lexington Park. Honey Lane, pictured here, was a popular 24-hour bar, restaurant, and slot parlor located on Route 235. Other local watering holes included the Sunset Lounge, Brass Ass, Pat's Bar, Eddie's Nav-Air Grill, Cedar Point Tavern, the Dock, Two-Spot Club, Horseshoe Club, and Peach Blossom Inn.

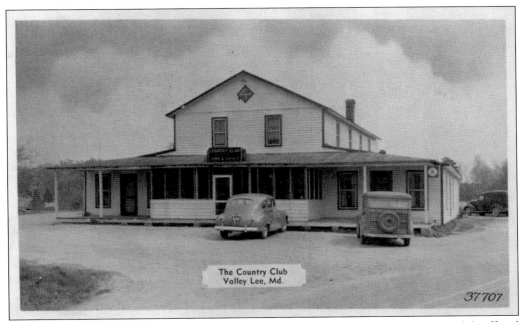

THE COUNTRY CLUB. Owned and operated by Bob and Helen Lohr, the Country Club offered dinner and cocktails near the intersection of Piney Point Road and Drayden Road in Valley Lee. The Second District Volunteer Fire Department and Rescue Squad Station is located on the site of this former restaurant.

TALL TIMBERS TAVERN. Decidedly off the beaten path, Tall Timbers Tavern was a popular restaurant, bar, motel, and dance pavilion located across from the Tall Timbers Post Office. The property is currently a private home.

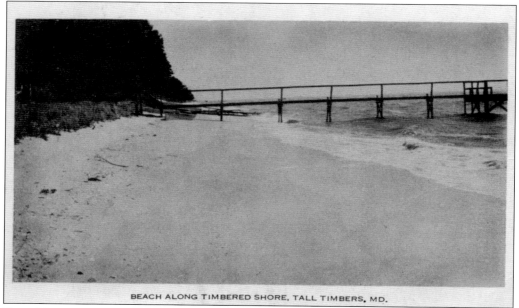

BEACH ALONG TIMBERED SHORE, TALL TIMBERS, MD.

TALL TIMBERS ON THE POTOMAC. In 1921, Henry Juenemann, a Washington, DC, resident, created a subdivision consisting of 40 lots known as Tall Timbers on the Potomac. These lots were marketed to Washingtonians for summer homes. Residents enjoyed both the Potomac River's cooling breezes and the area's ready supply of bootleg whiskey, which was harder to come by "up the road."

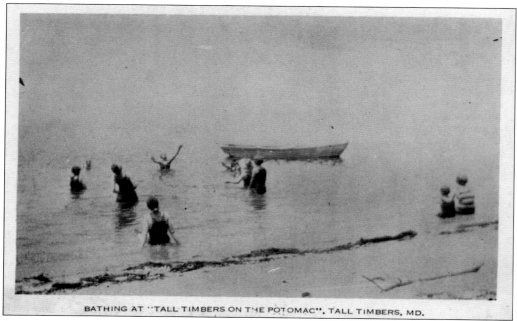

BATHING AT "TALL TIMBERS ON THE POTOMAC", TALL TIMBERS, MD.

POTOMAC SHORELINE. Through the 1940s, Tall Timbers had a sizeable sandy beach offering a perfect spot for swimming and sunbathing. Erosion eventually claimed the beach, requiring the installation of an extensive seawall and riprap.

120

FIRESIDE IN ALL-YEAR COTTAGE AT
"TALL TIMBERS ON THE POTOMAC"

COTTAGE INTERIOR. While most of Tall Timbers's cottages were summer homes, a few had year-round residents. This image from the early 1930s shows the living room from a year-round cottage.

"Sunset" St. Marys City
St. Marys County, Maryland

GETAWAY FOR THE WELL-HEELED. Despite its rural location, St. Mary's County has always been a popular place for waterfront vacation homes. The home pictured here, which overlooks the St. Mary's River, was built in 1919 by Harry S. Wherrett, the president of the Pittsburgh Plate Glass Company. In 1959, the property was acquired by Francis and Loretta "Tiny" Taylor.

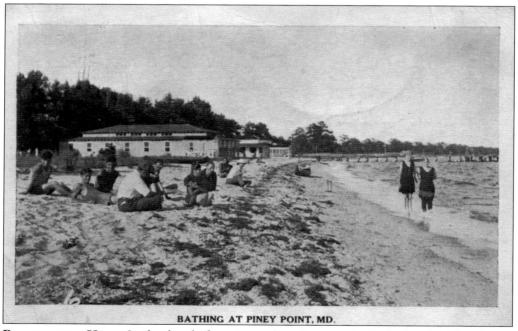

BATHING AT PINEY POINT, MD.

BEATING THE HEAT. In the days before air-conditioning, people flocked to local beaches to escape Maryland's summer heat and humidity. This picture, taken in the 1930s, shows a group cooling off on the banks of the Potomac River at Piney Point.

122

LIGHTHOUSE ROAD GAZEBOS. In Piney Point, gazebos and summerhouses dot the beach along Lighthouse Road. The area is known for its relaxed lifestyle and neighborhood gatherings.

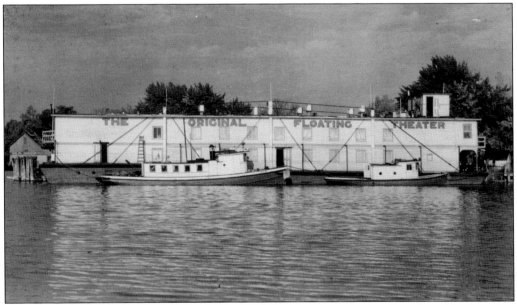

JAMES ADAMS FLOATING THEATER. In 1913, James Adams, a vaudeville trouper, built a 128-foot barge to bring the arts to residents living in the Chesapeake Bay's coastal towns and rural villages. His floating theater seated 850 and played six nights at each stop, offering a different program each night. Pictured here at the Leonardtown Wharf in the 1920s, the barge inspired Edna Ferber's novel *Show Boat*, which led to a Broadway hit of the same name. (Courtesy of St. Mary's County Historical Society.)

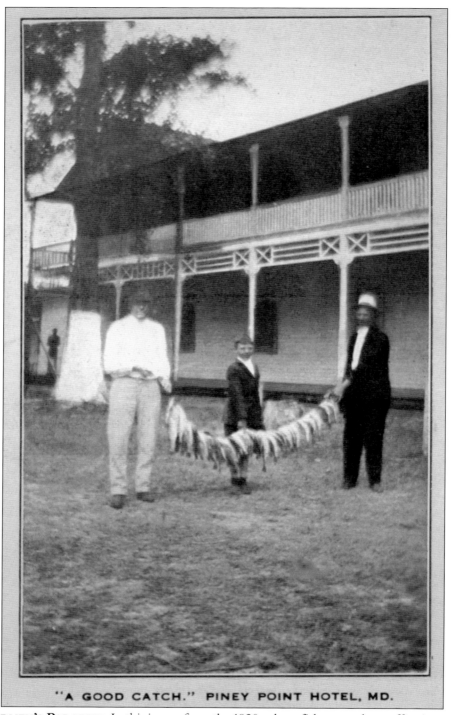

"A GOOD CATCH." PINEY POINT HOTEL, MD.

FISHERMEN'S PARADISE. In this image from the 1920s, three fishermen show off an impressive day's catch. Commercial and sport fishermen still flock to St. Mary's in search of rockfish, croaker, flounder, bluefish, spot, mackerel, white perch, and catfish.

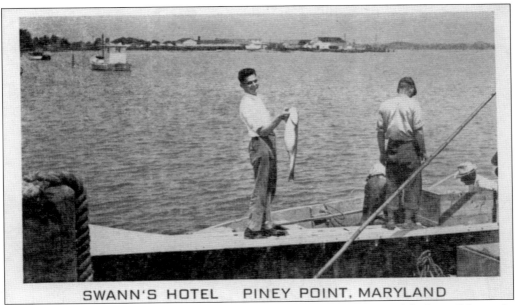

SWANN'S HOTEL PINEY POINT, MARYLAND

FISHING ON ST. GEORGE'S CREEK. A beaming fisherman displays one of the large fish caught in St. George's Creek near Swann's Hotel. After World War II, the creek was frequently the site of outboard powerboat racing events sponsored by the Southern Maryland Boat Club.

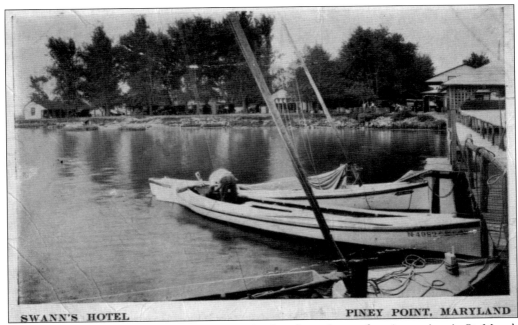

SWANN'S HOTEL PINEY POINT, MARYLAND

BOATING ON POTOMAC TRIBUTARIES. Boating has always been a favorite pastime in St. Mary's County. Whether touring by kayak, canoe, sail, or power, boaters enjoy hundreds of miles of creeks, tidal inlets, and open water.

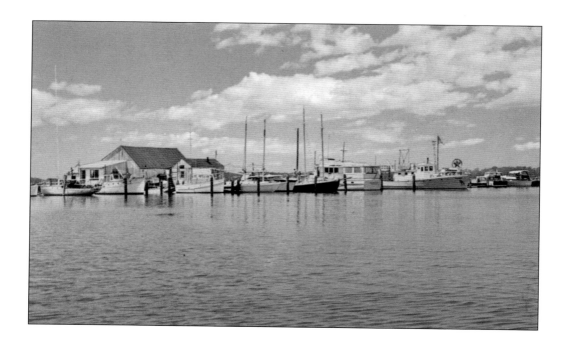

CLAYTON MARINA. Commercial marinas have dotted the waters of St. Mary's County for decades. Clayton Marina, pictured above and below in the 1970s, is one of the largest in Southern Maryland. Now known as Point Lookout Marina, it offers both transient and long-term dockage at the junction of Smith and Jutland Creeks.

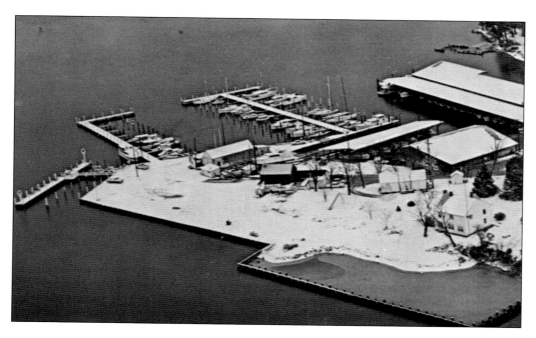

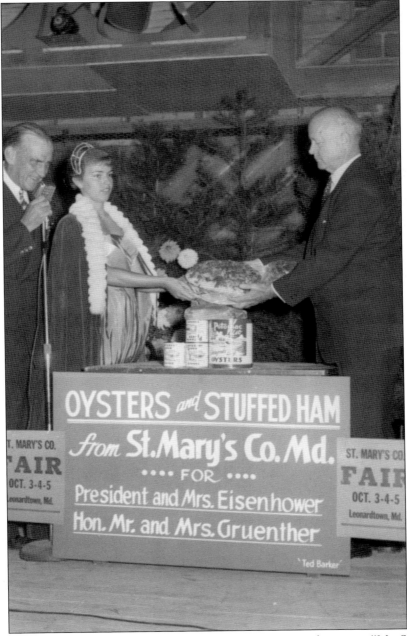

A GIFT FOR THE PRESIDENT. Arthur Fenner Lee "Buck" Briscoe, known as "Mr. St. Mary's," and Susan Blake, the Queen of Tolerance for the 1958 St. Mary's County Fair, present stuffed ham and oysters to Homer Gruenther, assistant to the deputy assistant to Pres. Dwight Eisenhower. In a letter dated October 18, 1958, President Eisenhower expresses deep gratitude to the people of St. Mary's for the "fine country ham and fresh oysters." Stuffed ham is found only in Southern Maryland and in areas of Kentucky settled by people from Southern Maryland. The origin of stuffed ham is a mystery, but many suggest enslaved Africans developed the recipe by adding red pepper to boiled pork, greens, and onions. (Courtesy of St. Mary's County Historical Society.)

DISCOVER THOUSANDS OF LOCAL HISTORY BOOKS FEATURING MILLIONS OF VINTAGE IMAGES

Arcadia Publishing, the leading local history publisher in the United States, is committed to making history accessible and meaningful through publishing books that celebrate and preserve the heritage of America's people and places.

Find more books like this at
www.arcadiapublishing.com

Search for your hometown history, your old stomping grounds, and even your favorite sports team.

Consistent with our mission to preserve history on a local level, this book was printed in South Carolina on American-made paper and manufactured entirely in the United States. Products carrying the accredited Forest Stewardship Council (FSC) label are printed on 100 percent FSC-certified paper.

MADE IN THE
USA